ART TURNING LEFT

HOW VALUES CHANGED MAKING 1789-2013

Edited by Eleanor Clayton, Francesco Manacorda and Lynn Wray

FOREWORD

The emotional power of images has always linked artistic production to political campaigning, leading artists to put their work at the service of different causes. Rarely has the reverse effect, of political thinking impacting upon the making of art, been investigated. *Art Turning Left* is both an exhibition project and a publication focusing on this lesser explored aspect of the relationship: rather than looking at political artwork it attempts to trace a lineage for work intended to be made politically. Instead of propaganda and direct political messaging, this project follows how artists went a long way to change how art is made and shown in order to be coherent with their political and ethical principles. Sometimes these are visible and expressed directly in the work as subject matter, but more often they are embedded in the process that brought the work to life. Arguably, the most eminent examples of the latter are William Morris' wallpapers: socialist principles are used to organise production rather than made evident on the visual surface of the work.

The exhibition format at Tate Liverpool takes inspiration from some of the works in its spatial and conceptual organisation. Eschewing chronology, the works are organised around questions such as how art can infiltrate everyday life, or whether participation delivers equality, in order to point out how artists found themselves struggling with similar dilemmas across different historical periods, finding different solutions. The diversity of materials assembled in each room points at how the political values inspiring the works might not reside on the work's subject matter but rather on the process of making and the position taken by the artists in relation to the production conventions of his or her time. The gathering of multiple answers connected to a shared question is also meant to encourage visitors to formulate their own interpretation of the works, taking an active position vis-à-vis their proposed question in relation to certain political values. Conversely, this publication provides its reader with a strictly chronological sequence of pictures and documents that have formed part of the research that not necessarily are part of the exhibition. More a supplement than a document of the show, this publication is designed as an alternative guide to the subject led by images as a historically generated visual essay.

This exhibition project was conceived by the Collaborative PHD Lynn Wray originally in dialogue with Christoph Grunenberg, former Director Tate Liverpool, and Peter Gorschlüter, former Head of Exhibitions and Displays; her lively and original contribution to this project has been really precious. We are deeply indebted to all of the private collectors, public museums and archives who have generously lent their works to be part of the show or published here, and especially to the artists whose collaboration in realising the exhibition has been invaluable. Certain colleagues external to Tate have also played an important role in the development of the show and publication, including Lars Bang Larsen, Bryan Biggs, Claire Bishop, John Byrne, Juan Cruz, Nicholas Cullinan, Alex Farquharson, Jacopo Galimberti, Suzannah Gilbert, Jonathan Harris, Antony Hudek, Alistair Hudson, Hari Kunzru,

Lisa Le Feuvre, Pablo Lafuente, Maria Lind, Ruth Noack, Olivia Plender, Alison Rowley, Julie Sheldon, Barbara Steveni, Adam Sutherland, Sally Tallant and Sarah Wilson. Furthermore, Tate colleagues Achim Borchardt-Hume, Matthew Gale, Simon Grant, Elvira Dyangani Ose, Andrew Wilson, and Catherine Wood have offered valued advice in the search for artists working with left-wing values at the heart of their process.

As ever, our gratitude goes to the dedicated staff of Tate Liverpool. Eleanor Clayton's passionate involvement as co-curator has been instrumental from concept to delivery of this complex and ambitious project. Once again, Sivan Amar, Barry Bentley and Ken Simons managed the complicated shipping and extensive installation, working closely with Julie McDermott, Roger Sinek and our trusted team of art handling technicians. We would like to thank our colleagues in collection care and conservation for their expertise and consideration, and Jemima Pyne, Ian Malone, Laura Deveney and James 'Connor' Craig for their efficiency and enthusiasm in the production of this publication. Furthermore, it has been a great pleasure to work with our Learning team in creating the Office of Useful Art, a space within the exhibition to host debate about the practices touched upon in both the exhibition and publication.

This exhibition has been made possible by the provision of insurance through the Government Indemnity Scheme, and Tate Liverpool would like to thank H M Government for providing Government Indemnity and the Department for Culture, Media and Sport and the Arts Council England for arranging the indemnity of works. We have been delighted to work closely on this project with Liverpool John Moores University, whose institutional foundation and ethos correspond with the concept of this exhibition. The University has provided generous sponsorship and their students have participated in the running and preparation for the Office of Useful Art, as well as curating an element within the show, giving extra depth to the partnership.

Tate Liverpool and Liverpool John Moores University have a long-standing relationship which this partnership builds on. We would like to offer our particular thanks to Professor Nigel Weatherill, LJMU Vice Chancellor; Professor Juan Cruz, Director of LJMU School of Art and Design; Janet Martin, LJMU Director of Corporate Communications and Shonagh Wilkie, LJMU Corporate Communications Manager, for the support and energy they have brought to the project.

These collaborations enabled us to approach the project in a spirit completely aligned to the exhibition's theme, working collectively to produce something that is beyond the possibilities of the individual. We very much hope that the partnerships that this project has brought about will continue beyond it and into the future.

Andrea Nixon, Executive Director
Francesco Manacorda, Artistic Director

KNOWLEDGE IS POWER

In 1825, a small institution helped revolutionise education in Liverpool. That institution was the forerunner of Liverpool John Moores University (LJMU). Over 180 years have elapsed since the Liverpool Mechanics Institute first opened the doors of learning to the ordinary working men and women of Liverpool but still the revolutionary zeal beats hard and fast in what is now one of the UK's largest universities.

The Institute's mission was to open up educational opportunity for all, and under the aegis of its stirring motto "Knowledge is Power" many citizens feared that the very social order of nineteenth century Liverpool was under threat. While the revolution that followed eschewed violent protests, it was none the less radical in its reach and impact as it would help change the nature and importance of art education in British higher education.

Now located in the RIBA-award winning John Lennon Art and Design Building, the Liverpool School of Art's multi-disciplinary approach combines contemporary developments in digital content and innovative practices with the rich heritage of traditional arts education. Just as in 1825, the School maintains its connections with industry, commerce and the local community, with students from fine art, fashion, graphic and spatial design and architecture interacting with each other, sharing ideas and embarking on new creative journeys together.

LJMU has a clear sense of our place within Liverpool, a true city of the world, but our aim is to be recognised globally as a modern civic university, which has an influence that resonates far beyond the banks of the Mersey and the UK. That's why we are encouraging all students across the institution to engage not just with the Art Turning Left exhibition but with everything that Tate Liverpool and the city's exciting visual arts and cultural sector has to offer. Such engagement can, we believe, inspire our students to question more, to become more willing to take risks, and motivate them to become agents for positive change in whatever sector they choose to work in.

Stimulating debate and generating new thinking, ideas and solutions to the challenges of the 21st century are the heart of everything we do as a University. Investing in and connecting with Liverpool's cultural sector is a crucial part of this agenda and we look forward to further consolidating our longstanding partnership with Tate Liverpool in the years to come.

Liverpool John Moores University

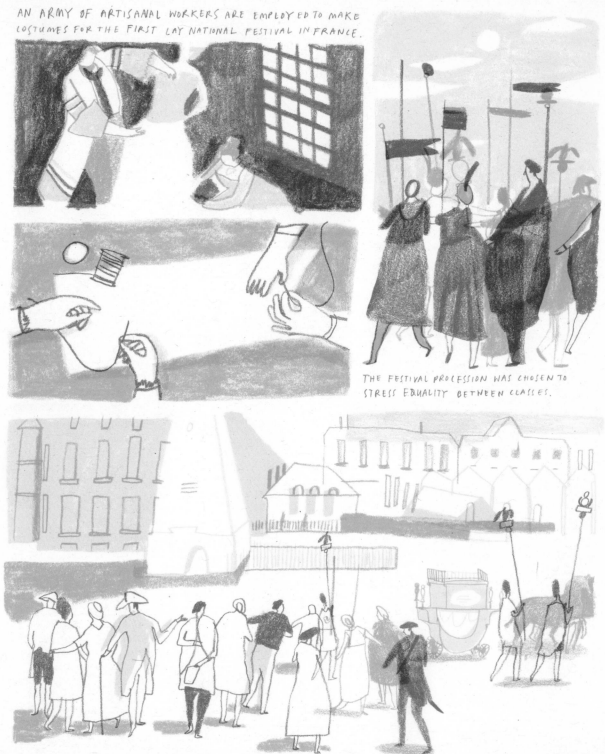

AN ARMY OF ARTISANAL WORKERS ARE EMPLOYED TO MAKE COSTUMES FOR THE FIRST LAY NATIONAL FESTIVAL IN FRANCE.

THE FESTIVAL PROCESSION WAS CHOSEN TO STRESS EQUALITY BETWEEN CLASSES.

ART TURNING LEFT

by Lynn Wray

Illustrations by Rachel Gannon

PUTTING POLITICAL VALUES INTO PRACTICE

There are three core values that are common to all left-wing ideologies: the belief in equality rather than hierarchy, the quest for social progress over the maintenance of the status quo, and the conviction that the benefits of collectivism and solidarity exceed the gains of competitive individualism. There is also a shared concern with combating the alienation caused by capitalist modes of production, either by creating alternative economic systems or by mediating the worst effects of capitalism through the development of different forms of production and distribution. These values have concerned artists for more than two centuries and have had a dramatic and sustained effect on the way they make their work. This pervasive and recurrent impact of political values on art-making is the subject of this exhibition and its accompanying publication.

The research and development of this exhibition focused, first, on identifying works that elucidate the ways in which the key values of leftist ideologies have influenced the strategies and techniques that artists use to put their political values into practice. Secondly, it has been concerned with creating incongruous juxtapositions and counter-intuitive groupings from these examples, in order to encourage viewers to focus critically on the ways in which artists adopted processes that manifested their ideals.

This approach was inspired by Bertolt Brecht's photobook *War Primer*, in which he juxtaposed images cut from popular magazines with his own four-line epigrams, providing alternative captions to what Brecht described as 'inherently bourgeois' photographs. He wanted to create a distancing, alienating effect (in German, *Verfremdungseffekt*) which forced viewers out of passive consumption, thereby allowing them to examine critically the capitalist ideology he felt was propagated through these images. Some of these groupings and juxtapositions found a place in the final exhibition, while others inhabit the show's narrative as recurring motifs that I shall examine in the following paragraphs.

Since the collapse of the Soviet Union and the end of the communist 'threat' there have been many exhibitions on the relationship between art and politics. However, they have focused almost exclusively on the contributions artists have made to politics rather than the influence of political ideologies on artists, generally concentrating on content rather than process. None has investigated the explicit impact of left-wing politics on arts practice. The strong association between artists and the political left goes back to the French Revolution, at which time established artist Jacques-Louis David became part of the revolutionary government and implemented some of their values into his practice. Notably, he sought to bring art to the masses, changing the manner that his own work was distributed as well as facilitating mass performative festivals incorporating public participation. The very idea of a political 'left' and 'right' is in itself a visual concept stemming from the spatial organisation of the meeting hall of the French legislative body during the Revolution. Similarly, the term 'avant-garde' was first used in relation to the arts by the utopian socialist Saint-Simon, who believed that, if artists worked together with engineers and industrialists, they could create a more egalitarian, progressive and equal society.

French Revolution Festivals, 1790–1799,
After the revolution several collective celebrations were set up to re-enact or consolidate its political values amongst French citizens.

SOCIAL PROGRESS: FROM ALIENATION TO AGENCY

In order to increase the agency of the viewer, Brecht proposed the paradoxical approach of using an alienation effect in his works, precisely to counter the alienating outcome of capitalist life. This strategy was derived from the Marxist method of dialectical materialism, and developed by Erwin Piscator in his Epic Theatre. It is a practice that not only influenced generations of theatre directors, but also had a profound impact on left-wing artists. In this supplement alone there are many examples: Chto Delat and Wendelien van Oldenborgh employ these theatrical techniques in the production of their performances and films, whereas Jo Spence and the Hackney Flashers, Allan Sekula, the Mass Observation movement, the Situationists and Josep Renau are all concerned with subverting capitalist imagery in order to defamiliarise it and thus increase viewers' ability to question what they see and distance themselves from the ideological pull of the spectacle.

William Morris' own interpretation of Marx' theories of alienation led him to a completely different strategy. He believed that the most critical problem in capitalist society was the alienation of workers caused by the division of labour. Workers became alienated from themselves because they were not involved in artisanal craft within production and were thereby deprived of pleasure in their work and of the right to creative production. In addition, as the industrialist made a profit by extracting surplus value from the workers' labour time, the workers were often prevented from buying and using the objects they produced and thus became alienated from what they made. Morris forged a greatly expanded definition of art which, going beyond professionalised art, included any form of creative labour undertaken by any person. Reorganising the modes of production so that all workers could work creatively was the basis of Morris' true revolutionary art: the politics lay in the production process rather than in the content.

Although he was unable to achieve the intended return to a system of craft guilds, Morris refined his fabrication processes to the highest level and allowed his workers to employ their creativity in the production of wallpapers, chairs, books and textiles that would infuse political values into both everyday objects and labour.

Morris' theory and practice were continued by many other left-wing artists. The most direct manifestation materialised in 1920s Germany at the Bauhaus. Walter Gropius's original Bauhaus idea was developed from a survey asking how a new socialist art could be formulated, organised by the socialist Arbeitsrat für Kunst (Workers' Council for Art) that Gropius chaired. His primary aim for the Bauhaus was to break down false hierarchies between art and craft, which he believed were determined by class. However, where Gropius differed from Morris was in his intention to achieve these ideals using the means of production of his own time, recognising that industrial production, as opposed to handicraft, was an unprecedented vehicle for collective reception. He wanted to imbue the design of industrial products with the values and techniques of craftsmanship, believing that these values would dis-alienate the processes of mass production and ensure the subordination of the machine to humanity's needs.

Morris' influence can also be seen in schemes developed by artists and revolutionary governments to create equality of access and to increase the agency of ordinary people. These involve the creation of opportunity and the resources for people to participate in the production of artworks but also, crucially, the chance for their works to be seen and recognised to be as valid as those of professional artists.

William Morris (1834 –1896) was an English textile designer, artist, writer, and libertarian Marxist associated with the Pre-Raphaelite Brotherhood and English Arts and Crafts Movement.

THE PROBLEM WITH MODERN SOCIETY IS THE 'USELESS TOIL' OF MECHANISED PRODUCTION.

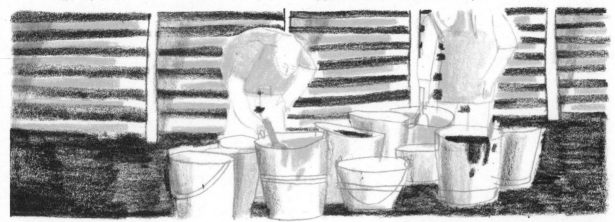

WE NEED TO FUSE
CRAFT VALUES WITH
MODERN PRODUCTION
TO CREATE
'USEFUL
WORK'...

...WHERE THE LABOURER
WOULD HAVE THE PLEASURE
OF USING HIS INTELLECT
AND SKILL TO MAKE...

...BEAUTIFUL THINGS

The Worker Photography Movement (see p32), largely organised by communist periodicals across the globe, such as the German magazine AIZ (*Arbeiter-Illustrierte-Zeitung*, meaning 'Workers' Pictorial Newspaper'), is a crucial example. Conversely, the Constructivist project led by Varvara Stepanova, Aleksandr Rodchenko and Lyubov Popova in revolutionary Russia (see p26, 28 and 30), as well as the Cuban revolutionary government's 'Art in the Factory' and 'Telearte' schemes (see p57), brought professional artists directly into industrial production processes in order to investigate how workers could have more creative input in their work. The use of optical effects in the designs of the Constructivists was further intended to activate the minds of viewers and bring about their political agency. This can be considered another leitmotif of the exhibition, common to the Neo-Impressionists, the Cuban poster designs of OSPAAAL (see p49), Emory Douglas' illustrations for the Black Panther newspaper (see p49) and the games and sensorial machines of the French collective GRAV (see p43).

COLLECTIVISM: FROM INDIVIDUAL GENIUS TO SCIENTIFIC RESEARCH TEAMS

Collective creative practice has also been an important mode of artistic production throughout the twentieth century. Its political character not only puts into practice values of collective ownership and production, but also radically questions the notion of the artist as an autonomous genius working in isolation from society. Atelier Populaire, for example, had collective ownership over the means of production and, most importantly, developed shared motifs, producing art by committee and eschewing the artist's signature. With similar goals many artists have also conceived quasi-scientific or objective techniques to produce their work. For these groups, the purpose of using a codified methodology was its ability to be taught, shared and therefore used collectively to formulate and communicate a consistent and collective political vision.

This idea is in direct opposition to the romantic and bourgeois conception that art should be the self-expression of only a select few individuals' spiritual being and a product of their unique genius.

The scientific positivism of anarchist-communism, for example, inspired Paul Signac to develop Georges Seurat's pointillist technique into a collective scientific methodology he called 'divisionism', based on the theories of 'psychobiophysicist' Charles Henry and the colour theory of the chemist Michel Eugène Chevreul. Signac believed this would provide an alternative to the perceived social uselessness of Impressionism and debunk the illusion of artists as individual geniuses. The desire of some of the Neo-Impressionists to develop a shared technique rather than pursuing individual styles was motivated by their mutual belief in the collectivist principles of anarchist-communism, which proposed that the only way to guarantee individual freedom was to work collectively to overcome inequality. Their ideal society was a network of small, decentralised communes that worked on the principles of mutual aid and voluntary collectivism inspired by artisanal and rural communities, imagining themselves as an active community of sensory researchers. The scientific basis of the divisionist method would allow a community of artists to produce a collective statement through the application of a uniform method, while still retaining the autonomy of producing their work on an individual basis.

The Marxist Spanish collective Equipo 57 understood the idea of the isolated artist as a false freedom that removed artists from their social consciousness, to the detriment of their artistic and personal development. As for the Neo-Impressionists, for the Equipo 57 artists collective research and production was not a threat to the notion of autonomy and intellectual freedom: on the contrary, it was the best way of freeing artists from the shackles of competitive individualism and private ownership of knowledge.

Equipo 57 was a group of Spanish sculptors, architects and painters, founded in Paris, which was active between 1957 and 1962.

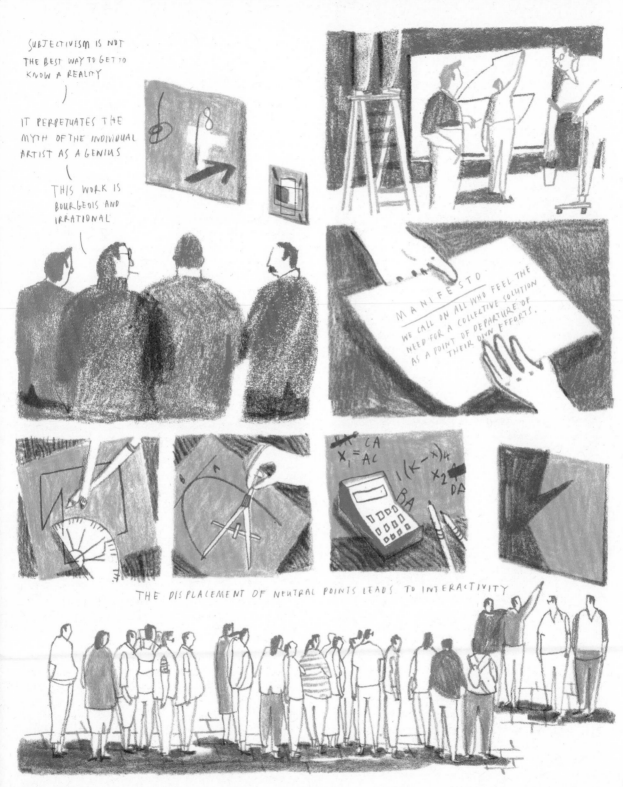

Living under Francisco Franco's dictatorship, Equipo 57 felt an urgent need for their art to stimulate a revolution. Echoing Saint-Simon's vision of the avant-garde, they believed that, if artistic practice could be transformed from individual production of objects into teams of researcher-artists producing shared knowledge, then art could play an active role in the transformation of society. They developed a new unified aesthetic, *The Interactivity of Plastic Space*, derived from mathematical formulae that could generate the most dynamic compositions for their paintings. They made these formulae publicly available to fine artists but also to architects and product designers in order to bring about socially useful art, fully integrated into everyday life. Equipo 57 produced and authored their work exclusively as a collective, and sought to collectivise visual research in order to create a system free from individual expression, owned by the whole community.

Further examples of artists' groups that have developed a 'quasi-scientific' methodology in order to collectivise knowledge include OHO, Komar and Melamid (p58) and the Mass Observation Movement (p34). The diagrammatic drawings of Slovenian art collective OHO were used to document and disseminate their performances, which were also created using an 'objective' method of 'rational programming' based on mathematical problems, such as Zeno's paradoxes. Komar and Melamid's *People's Choice* series of paintings were realised after instructions gathered using statistical information from a telephone poll about people's 'most and least wanted aspects' of paintings.

The Mass Observation Movement had used similar surveying techniques some 60 years previously, charting the opinions of Bolton residents about specially commissioned paintings with the intention of developing a new collective art. This project was part of Mass Observation's ambition to produce a collective picture of British society which was 'of the people, by the people, for the people', mixing methodologies derived from anthropology and surrealist collage.

Through revealing the political values that lay behind the production of both familiar and unfamiliar artworks, this show aims to bring to the fore a marginalised part of art history. It focuses solely on the left in order to stimulate people to consider what their own political values are, whether left-wing, right-wing or centrist, in relation to those highlighted in the show. The practices within the exhibition question the ways in which these values influence daily decisions; the show thereby aims to point out that everyone has both political and intellectual agency and the ability to shape or become part of this discourse.

ART TURNING LEFT

HOW VALUES CHANGED MAKING 1789-2013

Timeline

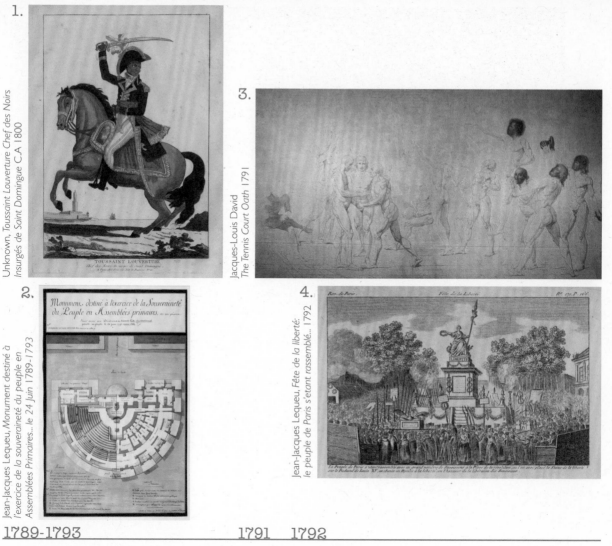

1. *Unknown, Toussaint Louverture Chef des Noirs Insurgés de Saint Domingue C.A 1800*

2. *Jean-Jacques Lequeu, Monument destiné à l'exercice de la souveraineté du peuple en Assemblées Primaires... le 24 Juin 1789-1793*

3. *Jacques-Louis David The Tennis Court Oath 1791*

4. *Jean-Jacques Lequeu, Fête de la liberté: le peuple de Paris s'étant rassemblé... 1792*

1789-1793 **1791** **1792**

1. The historical slave revolt in Haiti is often considered a parallel event connected to the French Revolution and the following Declaration of the Human Rights of 1789. In 1791 the French Revolutionary Government granted citizenship to wealthy free people of colour in what was then known as Saint-Domingue. The community of slaves, which was ten time bigger than those of whites and free people of colour, rebelled and started a revolt. They slowly gained control of the island. This later led to Maximilien Robespierre's abolition of slavery in France and all its colonies in 1794, which also

granted former slaves civil and political rights. Only in 1804, after years of battling, did Haiti gain its formal independence, ending colonialism on the island.

2. The political term 'left' came from the seating arrangement in the Estates General, in which those who sat on the left hand side of the assembly were in favour of the anti-monachist revolution.

3. The Tennis Court Oath is a legendary event that marks the onset of the French Revolution. The Oath was a pledge signed by

the members of the Third Estate – the one representing the commoners – which had been excluded from the Estates General assembly. Using a tennis court as an improvised meeting room, they declared themselves the National Assembly for all the people irrespective of class and decided 'not to separate, and to reassemble wherever circumstances require, until the constitution of the kingdom is established'. In 1789 the Estates General had not been summoned for more than 150 years and was only a consultative body, therefore the oath publicly

5.

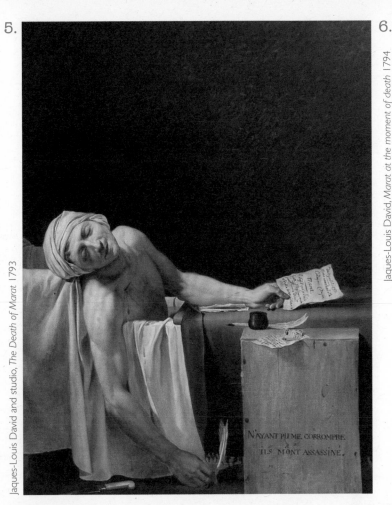

Jaques-Louis David and studio, *The Death of Marat* 1793

6.

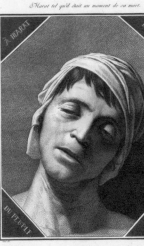

Jaques-Louis David, *Marat at the moment of death* 1794

1793 1794

put forward the lower classes' intention to conduct the nation's affairs. Jacques-Louis David immortalised the event in a famously unfinished painting, later printed in an iconic edition.

4. Several festivals were set up to rehearse key moments of the revolution and relive them collectively. In one of them, The Châteauvieux Regiment became famous when they rebelled against their aristocratic officers and were sent to the galleys as retribution. Recalling that the regiment had refused to fire on the people in July 1789, the people of the working class districts of Paris came out in support and called

for their release. A national festival was planned in honour of the Regiment who were suddenly conceptualised as 'the martyrs of liberty and the fatherland'. Jacques-Louis David was appointed as master of ceremonies for the festival held on April 15 1792. The procession started in the artisanal district of Faubourg Saint-Antoine with huge involvement of the Parisian working-class. From the people's first demands for it to take place, to their involvement in organising the festivities and their participation in the final procession, as Jacques-Pierrre Brissot proclaimed, 'the people were the regulator, the executor,

the ornament and the object of the celebration'.

5, 6. Revolutionary Jean-Paul Marat was killed in his bath by Girondin Charlotte Corday. Within months, Jacques-Louis David made this work which was used to create an image of Marat as a revolutionary martyr. David was very involved in the revolutionary government and its visual manifestations. He instructed his studio to make copies of the painting so these could be sent around the country to spread the revolutionary message, also making accessible art which would have previously been displayed only as a unique object in elite circles.

7.

The men of imagination will open the march: they will take the Golden Age from the past and offer it as a gift to future generations; they will make society pursue passionately the rise of its well-being, and they will do this by... making each member of society aware that everyone will soon have a share in enjoyments which up to now have been the privilege of an extremely small class; they will sing the blessings of civilization, and for the attainment of their goal they will use all the means of the arts, eloquence, poetry, painting, music; in a word, they will develop the poetic aspect of the new system.

Claude Henri De Saint Simon
from *L'organisation Sociale* 1825

8.

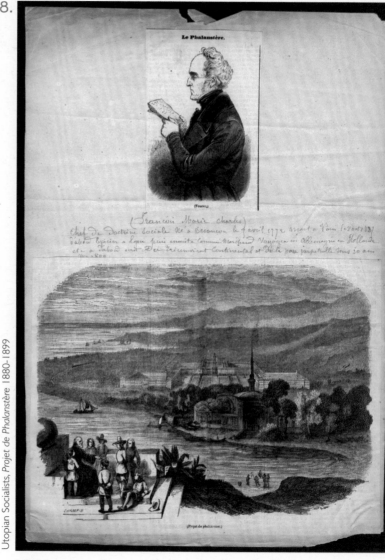

Utopian Socialists, *Projet de Phalanstère* 1880-1899

1825

c. 1830s

7. Claude-Henri de Saint Simon is considered the first 'Utopian' Socialist and had a significant impact on Karl Marx' philosophy. With the central aim of eradicating poverty he conceived of the foundation of a national community led by an avant-garde of industrialist scientists, engineers and artists and based on the values of productive labour, social progress, collective living and equality. He was the first person to use the term 'avant-garde' in relation to the arts.

8. Charles Fourier was a businessman from Lyon who believed social harmony was only achievable through collective work and communal living arrangements that maintained the importance of individual desires, needs and skills. Fourier proposed a network of independent communes, without a central state, called phalanxes, which consisted of approximately 1800 people based in huge buildings called Phalanstères. In each phalanx there was a complete system of

industrial functions and work was rationally divided, allowing for time to pursue scientific study and arts activities. 'Street galleries' would feature exhibitions of resident-produced art, murals would cover the communal interiors and sculptures would adorn the gardens. The community was not strictly egalitarian but even the poorest worker would be a co-owner of the whole project, and would receive a share of profits, even if smaller than others. Fourier hoped that these

9.

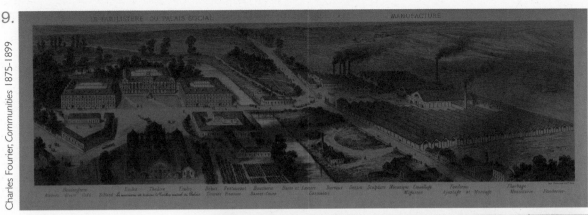

LE FAMILISTÈRE OU PALAIS SOCIAL · · MANUFACTURE

10.

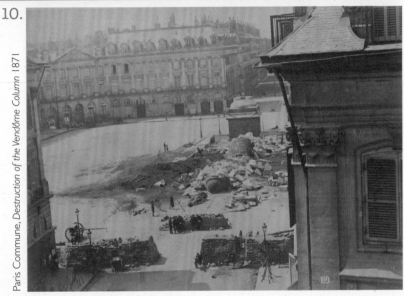

Paris Commune, Destruction of the Vendôme Column 1871

1875-99 **1871**

phalanxes would spread throughout the globe, where they would voluntarily organise themselves into decentralised system of departments, provinces and nations to achieve universal social harmony.

9. There were many attempts to turn Fourier's ideas into reality across Europe, Russia and America during the nineteenth century. Victor Considerant, Fourier's chief disciple, made two attempts. One in France in 1832 at Condé-sur-Vesgre and another called 'Reunion' in Texas in the mid-1850s, both quickly failed. However, the egalitarian businessman Jean-Baptiste-André Godin established a

successful phalanx called Familistére based on Fourier's ideas at Guise, France between 1859 and 1883. After Godin died he left the Familistére to the workers and they remained in control of it.

10. Gustav Courbet was a proponent of the Realist movement in France which addressed social issues by depicting the working conditions of the poor, a practice that challenged the conventions of the Academy. Courbet was also politically engaged, having declined the Legion of Honour offered by Napoleon III in 1870, thereby allying with those who opposed the regime. In 1871, periods of civil unrest following

France's defeat in the Franco-Prussian war led to the establishment of the Paris Commune, a socialist government set up by the largely working class. National Guard. Placed in charge of Paris' art museums for the Commune, Courbet proposed the dismantling of the Vendôme Column, a monument to the military successes of Louis XIV, due to both its lack of artistic merit and its symbolism of imperial might. The monument was dismantled on May 12 1871, an action documented by photographs which would later be used to incriminate the performers.

11.

I accounted the greatest of all evils, the heaviest of all slaveries; that evil of the greater part of the population being engaged for by far the most part of their lives in work, which at the best cannot interest them, or develop their best faculties, and at the worst (and that is the commonest, too) is mere unmitigated slavish toil, only to be wrung out of them by the sternest compulsion, a toil which they shirk all they can – small blame to them. And this toil degrades them into less than men: and they will some day come to know it, and cry out to be made men again, and art only can do it, and redeem them from this slavery; and I say once more that this is her highest and most glorious end and aim; and it is in her struggle to attain to it that she will most surely purify herself, and quicken her own aspirations towards perfection.

William Morris, from *Hopes and Fears for Art*, lecture delivered before the Birmingham Society of Arts and School of Design, February 19, 1880

12.

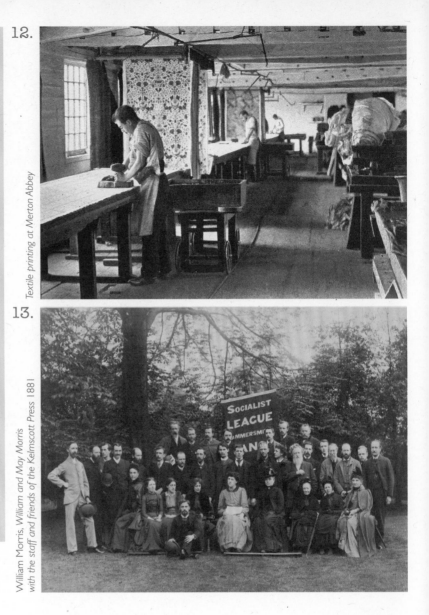

Textile printing at Merton Abbey

13.

William Morris, William and May Morris with the staff and friends of the Kelmscott Press 1881

11-14. William Morris was greatly influenced by the writings of Marx and became directly involved in active leftist politics from the mid-1870s onwards. He first became involved in the Social Democratic Federation and then later helped to set up a rival faction called the Socialist League. Morris was convinced that what was generally understood as fine art had no intrinsic revolutionary potential. Instead he saw the political value in an expanded definition of art, according to which real art was understood to be inherent in the process of making and the experience of living and as such to be any form of work that involved creative expression. Morris' reading of Marx' writing helped him to form a link between the alienation of the worker in his time and the removal of the creative process through division of labour in industrial and capitalist production. Morris came to believe that the

14.

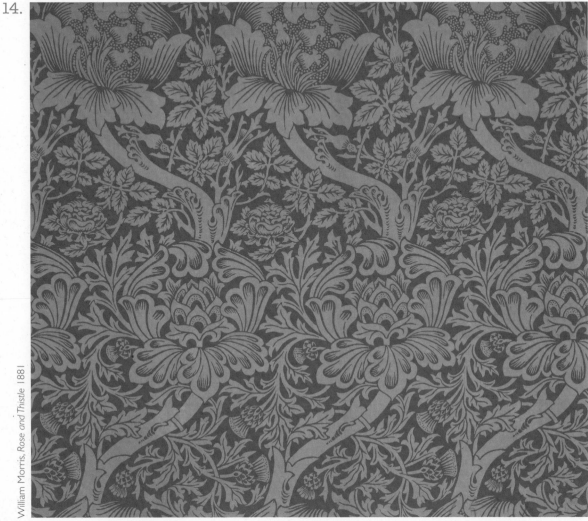

William Morris, *Rose and Thistle* 1881

essential problem with modern society was the 'useless toil' of mechanized production which alienated workers from the product they produced, as they did not fully make it and could not afford to own or use it. Morris' alternative to this was to fuse the craft values and artistry of medieval handiwork with modern production techniques in order to create 'useful work' where the labourer would be able to enjoy both the fruits of his labour and the pleasure of using his intellect and skill to make beautiful things. In his own art Morris spent countless hours perfecting his craft and his production processes in order to realise the finest products. For Morris the perfection of a craft or a process was what would make the maker happy and satisfied in his work and the user happy with the quality of the result.

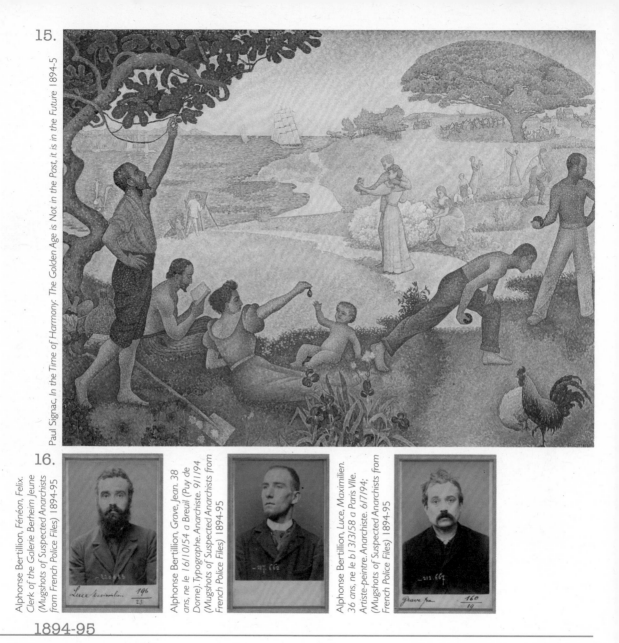

15.

Paul Signac, *In the Time of Harmony: The Golden Age is Not in the Past, it is in the Future* 1894-5

16.

Alphonse Bertillion, *Fénéon, Felix. Clerk of the Galerie Berheim Jeune (Mugshots of Suspected Anarchists from French Police Files)* 1894-95

Alphonse Bertillion, *Grave, Jean. 38 ans, ne le 16/10/54 a Breuil (Puy de Dome). Typographe.Anarchiste. 9/1/94 (Mugshots of Suspected Anarchists from French Police Files)* 1894-95

Alphonse Bertillion, *Luce, Maximilien. 36 ans, ne le b l 3/3/58 a Paris VIIe. Artiste-peintre.Anarchiste. 6/7/94; (Mugshots of Suspected Anarchists from French Police Files)* 1894-95

1894-95

15. Originally entitled *In the Time of Anarchy* this painting was intended to propagate the theories of anarchist-communists who believed that utopia could be achieved by combining communal rural practices with new scientific developments. However, it is not just the narrative content of the painting that confers the anarchist-communist ideal.

Signac's use of the pointillist technique was based on the theories of Charles Henry which advocated the use of dynamic line and contrasting colours to enable the active engagement of a viewer with the subject.

16. Many of the Neo-Impressionists were committed anarchist-communists.

Maximilien Luce was imprisoned in 1894 as part of the infamous 'Procés des Trente' (trial of the thirty) alongisde Jean Grave and Felix Fénéon for violating the law that outlawed the publication of visual art with anarchist themes. Luce produced a series of lithographs about his experience and was also the subject of the first ever police mugshots, taken

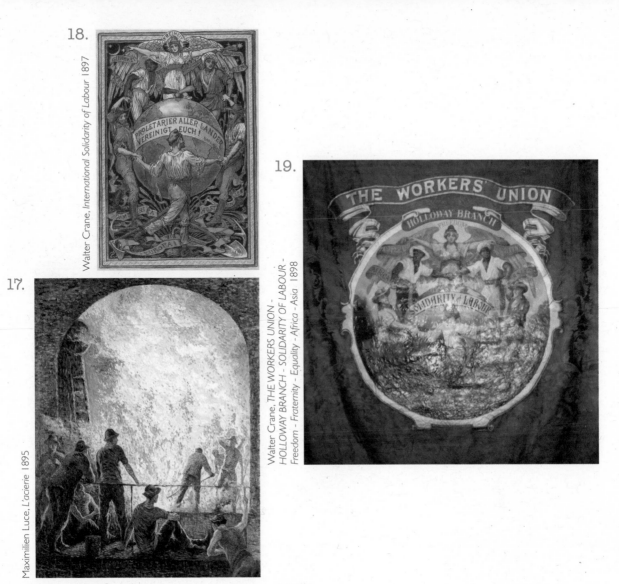

18. Walter Crane, *International Solidarity of Labour* 1897

19. Walter Crane, THE WORKERS UNION - HOLLOWAY BRANCH - SOLIDARITY OF LABOUR - Freedom - Fraternity - Equality - Africa - Asia 1898

17. Maximilien Luce, *L'acierie* 1895

1895 1897 1898

by the French police officer Alphonse Bertillion. Paul Signac contributed drawings and lithographs to the anarchist periodical 'Les Temps Nouveaux', and the Neo-Impressionists that had the means to do so also provided financial support for such publications.

17. Luce's *L'acierie* follows Signac's principles, and also similarly depicts individuals working together towards a

collective goal using the pointillist technique in which individual dots of colour combine to create a unified image.

18, 19. Famous for his illustration of children literature, Liverpool-born Walter Crane also produced images for the Socialist League's pamphlets and political cartoons for publications such as *Justice*, *Monopoly* and *The Clarion*. Like his friend William Morris, he was a member of the Arts and

Crafts movement. He used his art for the advancement of the political and social cause, aiming at bringing art to the enjoyment of all classes. Crane's drawing celebrating May Day depicts people from all continents uniting and was adopted as a symbol of international unity, freedom and the power of collectivity by workers unions in banners like this from c.1898, manufactured by the flag maker George Tutill.

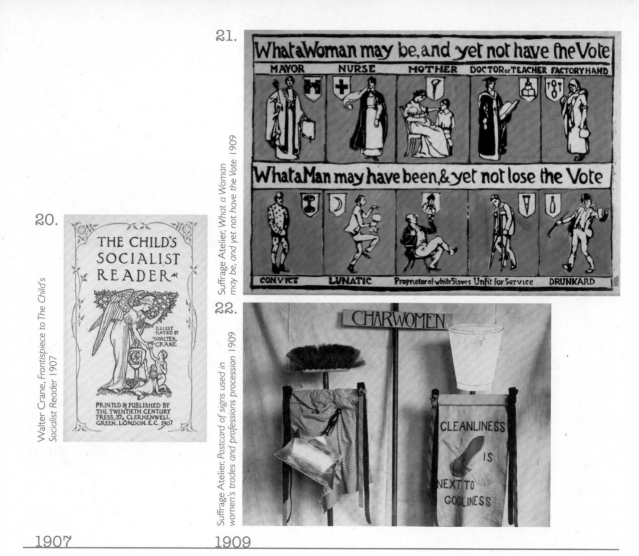

20. Walter Crane, *Frontispiece to The Child's Socialist Reader* 1907

21. Suffrage Atelier, *What a Woman may be, and yet not have the Vote* 1909

22. Suffrage Atelier, *Postcard of signs used in women's trades and professions procession* 1909

1907 1909

20. As a child illustrator Walter Crane also contributed to a socialist reader conceived for children and used in socialist Sunday schools. The book collects stories, allegorical tales, poems and pictures with political messages showing the injustices of the industrial revolution and pointing at alternatives to living conditions and socio-economic structures of the time.

21, 22. In 1909 members of the Women's Social and Political Union established by Emmeline Pankhurst founded the Suffrage Atelier with the task of preparing

material for demonstrations and political proselytism. The atelier was composed of illustrators as well as non-professional artists, and produced cartoons, posters and postcards. It also encouraged the artistic enfranchisement of women by running print workshops and open competitions.

23. The original manifesto of the Bauhaus, written whilst Gropius was chairman of the Arbeitsrat für Kunst, demonstrates that he hoped the Bauhaus would be a means of saving society from the continuation of useless bourgeois art by creating a more purposeful

art befitting of a socialist society. Gropius conceived of the Bauhaus as a collective enterprise that would work together as a new kind of 'guild of craftsmen' that was modelled on the form of community in a 'Bauhütte' – the medieval lodges where artists, artisans and builders came together to build cathedrals. The quote rearticulates Morris' ideas of reintroducing craft techniques into the production process as a means of combating the alienation of industrial production.

23.

25.

26.

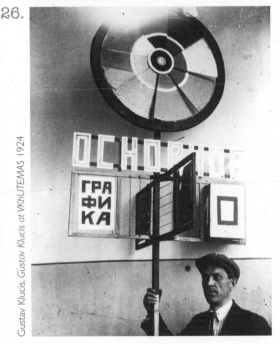

Gustav Klucis, *Gustav Klucis at VKhUTEMAS* 1924

24.

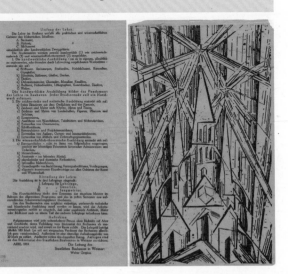

Lionel Feininger, *Cathedral*, title page for: *Manifesto und Programme of the State Bauhaus in Weimar* 1919

1919

24. Lionel Feininger's *Cathedral of Socialism* was intended to reflect the words of Gropius in the Bauhaus manifesto: 'Together lets us conceive and create the new building of the future, which will embrace architecture, sculpture and painting in one unity and which will rise one day toward heaven from the hands of one million workers like a crystal symbol of a new faith'. The use of woodcut and gothic symbolism represented an exaltation of the craftsman and referenced Morris' call for a gothic revival.

25. In 1919 Walter Gropius, together with César Klein, Otto Bartning and Adolf Behne, founded the Arbeitsrat für Kunst (Workers council for art). The organisation was explicitly socialist, named after the 'Arbeitsrat' (Marxist Worker's and Soldier's councils) in order to signal their intention of aligning themselves with the proletariat. They aimed to reunite art with the masses and create an organic and equal unity between all art forms, rejecting the hierarchical distinctions between disciplines and styles. Gropius was highly influenced by Morris' ideas for a socialist art and through the Arbeitsrat he called for a return to craft values and for artists to abandon their 'useless toil' and return to 'handwerk' through which they could become socially useful 'builders' again. They called for the development of 'people's housing' and for a government-financed crafts training programme that would help to bring the arts to all the people.

26. Having moved to Moscow in 1917, Gustav Klucis studied under Kazimir Malevich and Antoine Pevsner, becoming part of the Constructivist avant-garde. At this time he also joined the Communist party. His first notable project was his series of agitprop kiosks that were displayed around Moscow to celebrate five years of the revolution. These structures combined newspaper displays, film and sound – or 'Radio-Orators'- to give a multi-media experience of revolutionary life, embedded into day-to-day existence through their placement on the streets.

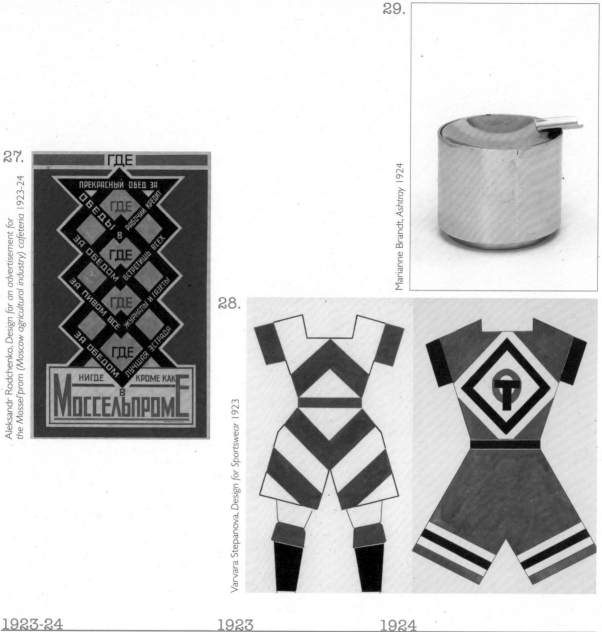

27.

29.

28.

1923-24 **1923** **1924**

27. In 1921 Aleksandr Rodchenko signed his agreement to a statement that urged for the move of 'art into life'. This consolidated a move away from painting and towards involvement in industrial production which had been discussed in previous years, with some artists literally

working alongside engineers in factories. Although not one of these, Rodchenko worked with futurist poet Vladimir Mayakovksy on advertisements for state run productions. The economic crisis had forced Lenin to allow some private companies to operate, so these advertisements supported

the revolutionary cause by incorporating constructivist aesthetic principles for practical use.

28. The uniforms of Soviet gymnasts designed by Varvara Stepanova enforce the idea of the individual existing only as part

30.

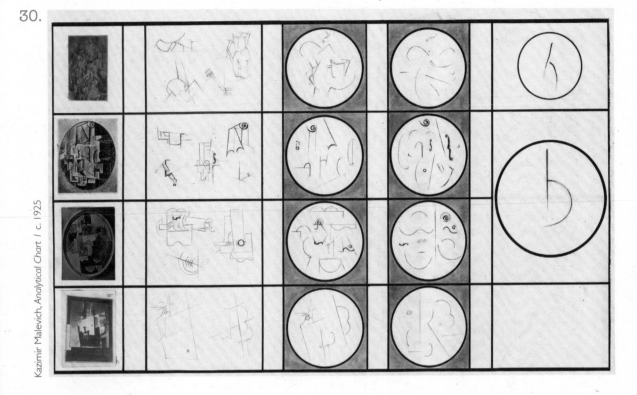

Kazimir Malevich, *Analytical Chart I* c. 1925

1925

of a larger collective pattern or vision, reflecting the collectivist policies of the Soviet Union. The costumes create a continuous geometric pattern from body to body, offering a mechanistic view of the human body as a disciplined collectivist and productive machine.

29. Marianne Brandt's iconic streamlined designs for teapots, lamps and ashtrays are representative of Gropius' central Bauhaus idea of introducing craft techniques into industrial production processes. Although Brandt's metalwork has an industrial aesthetic the majority were entirely hand-made. However, they were important steps in the process of combining her mastery of form with the functionalism of the object so that these high craft values could be transferred to the design of products for mass production.

30. Kazimir Malevich developed these charts when he was Director of the Russian Institute of Artistic Culture. He began to think of the development of painting as the development of an organism, devising with his students what he called the 'bacteriology of painting'. The charts indicated that an 'additional element' was added to each phase of abstraction to create the next, but that this was naturally occurring and 'gets into the painter', rather than being originated by the artist, disavowing the notion of individual creativity.

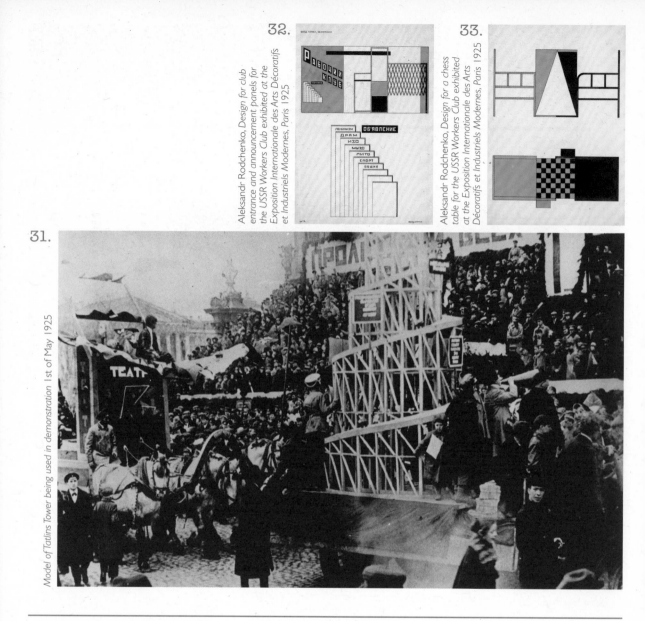

32.

Aleksandr Rodchenko, Design for club entrance and announcement panels for the USSR Workers Club exhibited at the Exposition Internationale des Arts Décoratifs et Industriels Modernes, Paris 1925

33.

Aleksandr Rodchenko, Design for a chess table for the USSR Workers Club exhibited at the Exposition Internationale des Arts Décoratifs et Industriels Modernes, Paris 1925

31.

Model of Tatlins Tower being used in demonstration 1st of May 1925

31. Vladimir Tatlin's *Monument to the Third International*, known as Tatlin's Tower, became an icon of revolutionary architecture both literally and figuratively. Designed to be both a monument to, and offices of, the then-government, the metal structure housed a glass cube, pyramid, and cylinder which all revolved at different speeds. The cube would complete one rotation a year and would house the highest government authorities, while the pyramid would rotate once a month and be occupied by a variety of committees. The cylinder would rotate once a day as a centre of propaganda, pumping radio waves into the sky and surrounding area. This high-concept building had such symbolic value that a model of it was paraded during Soviet demonstrations, despite never being built.

32, 33. Rodchenko designed a Workers Club to enable the proletariat to spend their time together collectively and productively. In the plans, bourgeois comfort is eschewed in favour of functional geometric design, including features such as a chess table, book case and places to read.

34.

35.

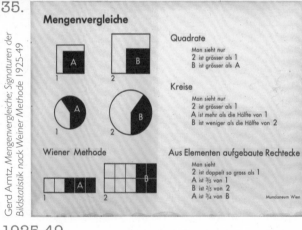

1925-30 1925-49

34, 35. Gerd Arntz, Heinrich Hoerle and Frans Seiwert were the leading members of the 'Gruppe progressiver Künstler Köln', a radical group of artists based between Cologne and Düsseldorf operating between the end of the 1920s and the rise of Nazism. Directly connected with communist unions, their goal was to use art at the service of the revolution, inventing a visual language able to contribute to the cause of the oppressed working class. Between 1929 and 1933 the group published the journal *A bis Z* with contributions of French artist Auguste Herbin, Russian architect Wladimir Krinski, Dutch artist Peter Alma and German photographer August Sander. Their formal language – typically using woodcut or linocut – was meant to communicate with everyone, avoiding art elitism and was designed for mass distribution rather than the bourgeois house or the museum. Such universal, transnational visual language was later expanded by Arntz in collaboration with Austrian philosopher and sociologist Otto Neurath, leading to the development of the Isotype, a visual alphabet consisting of repeatable pictograms which can be considered the progenitor of infographic as we know it today.

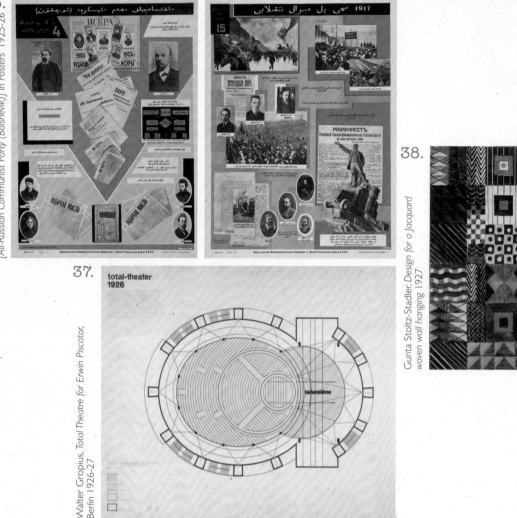

Aleksandr Rodchenko, From 'The History of the VKP(b)
[All-Russian Communist Party (Bolshevik)] in Posters' 1925-26

Gunta Stoltz-Stadler, Design for a Jacquard
woven wall hanging 1927

total-theater
1926

tiefenbühne

Walter Gropius, Total Theatre for Erwin Piscator,
Berlin 1926-27

1925-26 1926-27 1927

36. Factography was a politically
motivated practice often
attributed to Gustav Klucis,
adopted by many following the
Russian Revolution. A twist on
documentary, it embraced the
constructed nature of facts to
present an ordered reality
created through the process of
photomontage. Aleksandr
Rodchenko made his own version
of this, moving away from the
photomontage favoured by Klucis
to focus instead on using obscure
camera angles and juxtaposition
of single images to make the

familiar strange, encouraging a
re-appraisal of accepted reality.
Factography meant to fuse
journalism and diary writing with
image production, aiming at a
simultaneous collective reception.
This series *The History of the VKP
(b)* presented the Communist
Party's key moments.

37. Erwin Piscator was a left-wing
theatre director and the pioneer
of the 'epic theatre' technique
made famous by Bertolt Brecht,
who joined Piscator's company in
1927. The term 'epic theatre' is

associated with a group of authors
who advocated the avoidance of
illusionism to promote the
spectator's constant awareness
of theatre as an artificial
construction. Brecht's most
revolutionary technique, the
'estrangement effect', involves the
public's sudden effect of feeling
alienated from the fictional plot
to avoid identification with the
characters and their suspension
of disbelief. Interruptions, viewers
being directly addressed by actors
as well as open exposure of the
theatrical machine are examples

39.

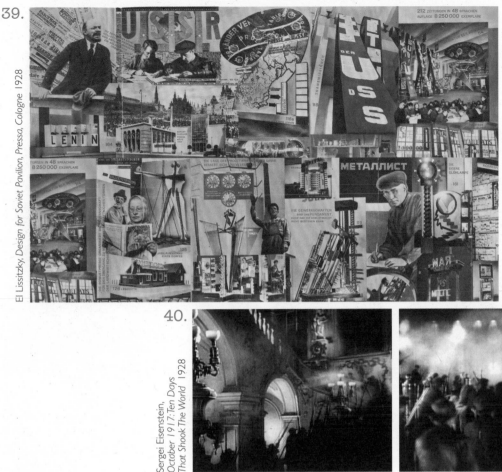

El Lissitzky, Design for Soviet Pavilion, Pressa, Cologne 1928

40.

Sergei Eisenstein,
October 1917: Ten Days
That Shook The World 1928

1928

of how this technique aimed at empowering the spectator and awakening his or her intelligence and political consciousness. Piscator was particularly known for his extravagant productions that used vast crowds, live projections, animated cartoons, turntables, treadmills and actors interacting with the audience. In 1926, with the aim of creating a theatre with a huge number of seats that could keep the admission prices low enough to attract a proletarian audience, he commissioned Gropius to produce this design. Gropius aimed to create a 'total theatre' that would unite architecture and theatre through mechanization and 'draw the spectator into the

drama [...] capable of shaking the spectator out of his lethargy, of surprising and assaulting him and obliging him to take a real interest in the play'.

38. Gunta Stolz was the Bauhaus' only female master, and became Director of Weaving in 1925. Under her directorship, this previously neglected part of the school became one of its most prominent facilities, successfully transitioning from a focus on individual craft items to modern designs for industrial production.

39. El Lissitzsky was a proponent of Factography, and one of the productivist artists who had moved away from painting in the

early 1920s. Alfred Barr, director of MoMA, noted of his visit to El Lissitzky in 1927, 'I asked whether he painted. He replied that he painted only when he had nothing else to do, and as that was never, never...' Most famous of his Factographic works was his design for the 1928 Pressa exhibition in Cologne which integrates photomontage, graphic and typographic design, described by the artist as a 'typographic kino-show' which was created with around 38 collaborators.

40. Sergei Eisenstein directed 'October 1917: Ten Days that Shook the World', a propaganda film commissioned to commemorate the 1917

31

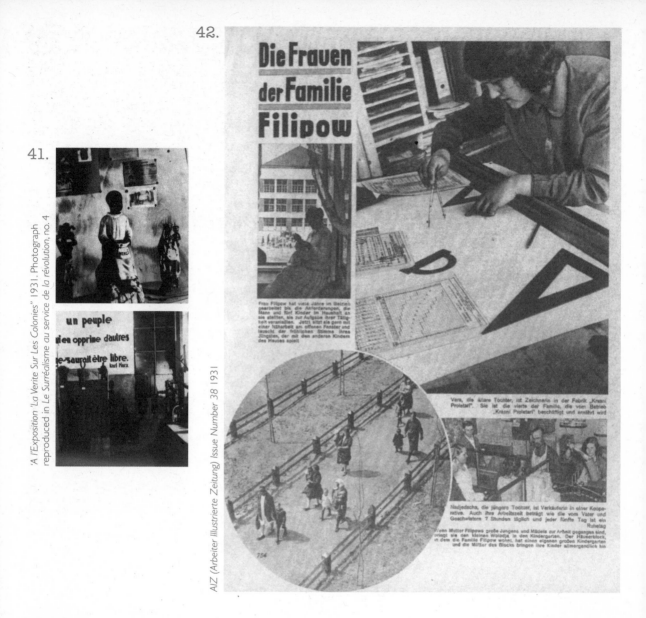

41.

Die Frauen der Familie Filipow

'A l'Exposition "La Verite Sur Les Colonies" 1931. Photograph reproduced in Le Surréalisme au service de la révolution, no. 4

AIZ (Arbeiter Illustrierte Zeitung) Issue Number 38 1931

1931

Russian revolution. Notably one of the scenes, the storming of the Winter Palace, was based on a 1920s restaging of the event which 'performed' by the Red Guard to an audience of over 10,000 people. Eisenstein described his directorial technique as 'intellectual montage', chiming with the constructed juxtapositions of factography.

41. *La verité sur les colonies* (The Truth around colonies) exhibition was organised in 1931 by the Ligue Anti-Imperialiste, the French Communist Party in collaboration with a group of Surrealist led by André Thirion and Louis Aragon. The show was the Surrealist reply to the simultaneous Exposition Coloniale in Paris. Featuring an incongruent combination of objects ranging from kitsch black madonnas and war toys alongside non-western objects, the show's political directions were indicated through images of Lenin and quotes by Marx on colonial oppression and collective emancipation.

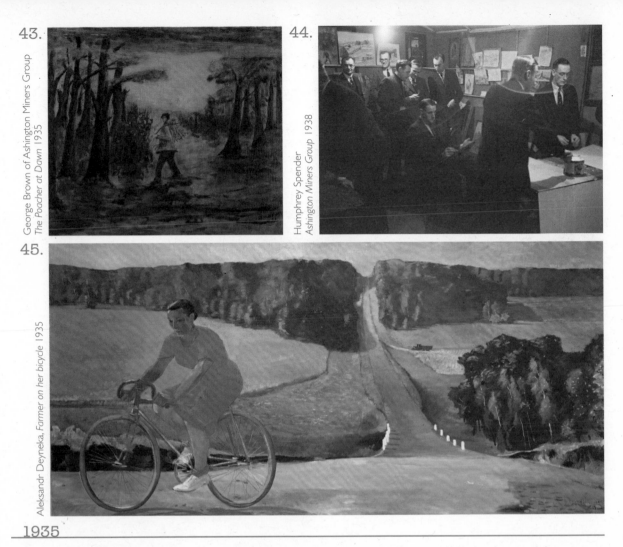

43.

George Brown of Ashington Miners Group
The Poacher at Dawn 1935

44.

Humphrey Spender
Ashington Miners Group 1938

45.

Aleksandr Deyneka, *Farmer on her bicycle 1935*

1935

42. A competition announced in AIZ (Arbeiter Illustrierte Zeitung, or Workers' Pictorial Newspaper) launched the Worker's Photography Movement, inviting images 'which present the daily life of the work in all its phases', among other criteria. This was prompted by a desire to move away from commercial image providers and democratise image making, AIZ noting that 'the capitalist news agencies flood the daily newspaper with tendentious news about world events... images from the life of the proletariat are unknown and are not being produced, because their diffusion does not further the interests of the capitalist employer'.

43, 44. In 1934 a group of miners in Ashington, Northumberland, were offered painting classes through their local Mechanics Institute, an organisation that offered further education through subscription. Their paintings became popular, with the workers becoming known as the Ashington Miners, and profits from the sale of their works went into the materials required to continue their practice.

45. With the 1931 decree 'On the Reconstruction of Literary and Art Organizations' Stalin established a theory and state guidelines for proletarian literature and art in the USSR that lasted until the 1980s. Its principles included the use of naturalistic representation of the heroes of the Revolution, a confident monumentality in size and relation to proletarian history, the development of a universal language understandable by everyone, and the avoidance of ambiguous and complex meaning. This kind of anti-modernist art performed a propaganda function and was deemed useful to the progress of socialist ideals.

46.

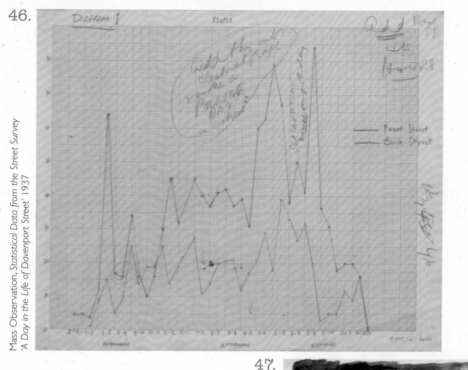

Mass Observation, Statistical Data from the Street Survey
'A Day in the Life of Davenport Street' 1937

47.

Julian Trevelyan
Rubbish May be Shot Here 1937

1937

46. The Mass Observation Movement was founded by a group of poets, artists and anthropologists in 1937 to create in their words, 'an anthropology of ourselves'. Their first published investigation was conducted in response to the coronation of King George V. Believing that the national press was not offering a reflection of general public opinion, the Mass Observation Movement collected material, from records of dreams the night before to interviews with the public and overheard comments. They also conducted long-term research in the northern industrial town of Bolton, known as 'Work Town' which documented the day-to-day lives of ordinary working people. This graph charts the number of hats worn on a particular street.

47. Julian Trevelyan was the first artist to be recruited by the Mass Observation Movement. *Rubbish May be Shot Here* combines the two projects of May 12th and Work Town, as the newspaper cut-outs are of children's heads featured in the run-up to the coronation combined with those of the royal family, but the factory background is inspired by Trevelyan's observations of Bolton.

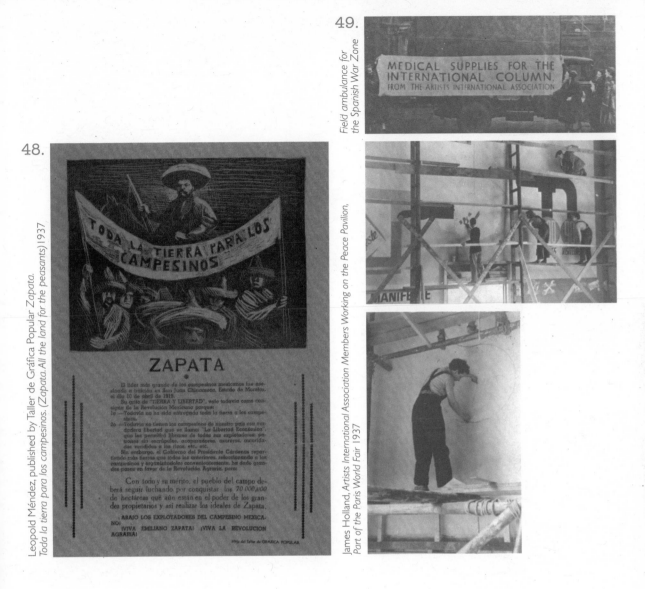

Field ambulance for the Spanish War Zone

MEDICAL SUPPLIES FOR THE INTERNATIONAL COLUMN FROM THE ARTISTS INTERNATIONAL ASSOCIATION

48.

Leopold Méndez, published by Taller de Gráfica Popular *Zapata.*
Toda la tierra para los campesinos. (Zapata.All the land for the peasants) 1937

TODA LA TIERRA PARA LOS CAMPESINOS

ZAPATA

James Holland, Artists International Association Members Working on the Peace Pavilion,
Part of the Paris World Fair 1937

48. The Taller de Gráfica Popular was founded in Mexico in 1937 by artists Leopoldo Méndez, Pablo O'Higgins, and Luis Arenal. The collective was primarily concerned with using art to advance revolutionary social causes such as anti-militarism, organized labour, and opposition to fascism. The art was often made through the collaborative process, and they had the anti-commercial policy of not numbering or editioning prints.

49. The Artist's International Association was founded in London out of discussions by Edward Ardizzone, Pearl Binder, Misha Black, James Boswell, James Fitton, James Holland and Clifford Rowe. Aims of the AIA included promoting peace and democracy, and advocating for wider access to art. They hoped to achieve this through holding exhibitions that would raise awareness of social and political issues, and were particularly active during the Spanish Civil War.

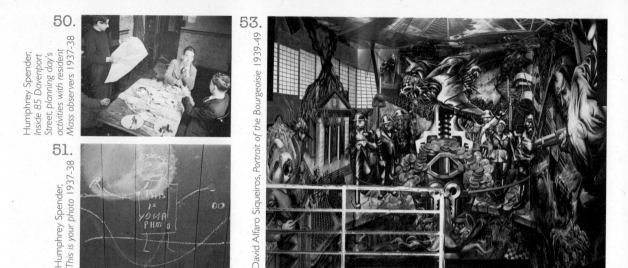

50.

Humphrey Spender;
*Inside 85 Davenport
Street, planning day's
activities with resident
Mass observers* 1937-38

51.

Humphrey Spender;
This is your photo 1937-38

52.

Charles Madge's, *Oxford Collective Poem* 1938

THE POEM

Believe the iron saints who stride the floods,
Lying in red and labouring for the dawn:
Steeples repeat their warnings; along the roads
Memorials stand, of children force has slain;
Expostulating with the winds they hear
Stone kings irresolute on a marble stair.

The tongues of torn boots flapping on the cobbles,
Their epitaphs, clack to the crawling hour.
The clock grows old inside the hollow tower;
It ticks and stops, and waits for me to tick,
And on the edges of the town redoubles
Thunder, announcing war's climacteric.

The hill has its death like us; the ravens gather;
Trees with their corpses lean towards the sky.
Christ's corn is mildewed and the wine gives out.
Smoke rises from the pipes whose smokers die.
And on our heads the crimes of our buried fathers
Burst in a hurricane and the rebels shout.

53.

David Alfaro Siqueiros, *Portrait of the Bourgeoisie* 1939-49

54.

Leonard Folgarait, *Mexican Electricans Syndicate* 1939-49

1938

1939-1949

50, 51. Humphrey Spender had
been working as a photographer
for the Daily Mirror when he
was asked to join the Mass
Observation Movement. He had
embraced using a particular
camera and 35mm film which
allowed him to take photographs
spontaneously on the street, some
of which he would accompany
with written observations.

52. Poet Charles Madge was one of
the Mass Observation Movements
three founders. Oxford Collective
Poem follows the principles of
Mass Observation that a collective
account is more valid than that
of an individual. It was composed
over a month by systematically
compiling observations from
12 Oxford undergraduate
students.

53, 54. David Alfaro Siqueiros
was one of the founders of
Mexican Muralism, and a political
activist. Following a spell fighting
against the fascist regime in the
Spanish Civil War, he returned
to Mexico to paint this mural
collaboratively with Josep Renau,
a Spanish refugee, and a collective
called The International Team of
Plastic Artists. The mural shows

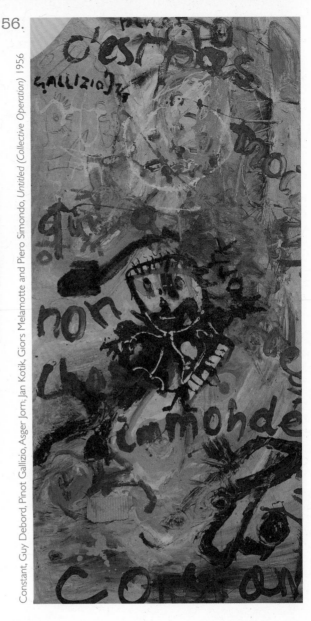

Constant, Guy Debord, Pinot Gallizio, Asger Jorn, Jan Kotik, Giors Melamotte and Piero Simondo, *Untitled (Collective Operation)* 1956

55.

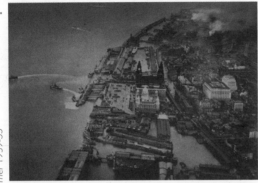

I am a city, but soon I shan't be—
Where generations used to live and die
Before those deadly birds flew in to haunt me:
One thousand years to build.
A fortnight to destroy.

Bertolt Brecht, *War Primer* 1939-55

1939-1955

1956

workers uniting under industrial advances, such as electricity, to continue to fight against capitalism and fascism.

55. The *War Primer* was compiled by Bertolt Brecht through World War 2, and published in 1955. Comprising newspaper cuttings collected during the war

accompanied by four line epigrams, the jarring juxtapositions encourage a reflection on the brutality of war, and its connection to capitalism. This technique using formal disjuncture to distance the viewer, enabling a fresh look at the world, recalls Brecht theatrical 'teaching' plays.

56. This work was made by participants in the First World Congress of Free Artists, organised by Asger Jorn and Pinot Gallizio, which addressed industrialisation and its impact on the notion of 'free art'. Each of the artists involved in its production has their signature visible.

Every aesthetic system
should have its age
and there is no art
without an aesthetic
system.

At present, we see
a need to introduce
scientific rationalism
in art in order to
create a unity of
style that will be the
true quotient of our
age... Art ceases to be
parochial, translating
private feelings, and
enters the broader
conscience of a
universal word

Equipo 57, *Notes for a
Manifesto* 1957

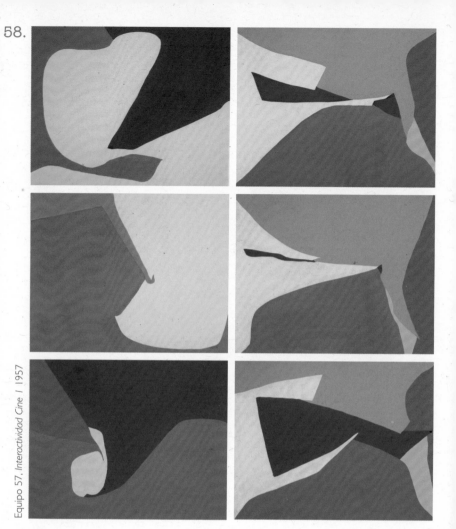

Equipo 57, *Interactividad Cine 1* 1957

1957

57, 58. Equipo 57 was a group of artists who aimed to utilise scientific theory in order to prevent individual gestures impinging on the creation of a universal aesthetic that could be collectively received. Their principle method, *The Interactivity of Plastic Space*, was published as a manifesto in November 1957 and emphasized the collective interdependence of elements of media such as form, colour, line and mass in a dynamic relationship with each other. Theycreated a series of rules for their practice that included using at least three colour spaces, at least two of these colour spaces must touch the outer edges of the painting and neutral points of straight lines must be displaced to create dynamism and interactivity. This was meant to instigate a transformation from individual to collective class-consciousness, thereby stimulating a desire for revolutionary social change. Their theoretical principles were made publically available for anyone to use and could be applied not only by fine artists but also by architects and product designers. They provided examples and diagrams that illustrated how to produce the most dynamic and active interrelations between elements of a composition.

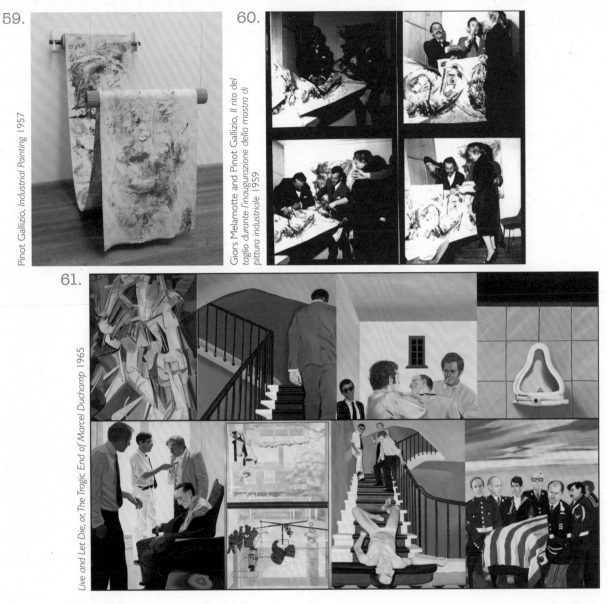

59.

Pinot Gallizio, *Industrial Painting* 1957

60.

Giors Melamotte and Pinot Gallizio, *Il rito del taglio durante l'inaugurazione della mostra di pittura industriale 1959*

61.

Live and Let Die, or, The Tragic End of Marcel Duchamp 1965

1959-1965

59, 60. Pinot Gallizio was a founding member of Situationist International, an artistic group that attempted to subvert the capitalist commodification of daily life. Gallizio's 'industrial painting' adapted mechanised manufacturing techniques to challenge established models for the production and distribution of art. The paint was applied onto long rolls of canvas by a team of assistants using a low-tech 'painting machine', so that the result was mass-produced but also unique. Gallizio would then cut off sections to be sold by the metre.

61. Live and Let Die Collective's work critiques the cult of the artist as unique genius, here represented by Duchamp as the founder of conceptual art in which the individual signature is key. A comic-strip like scene in which Duchamp is killed is executed in a manner that makes it impossible to tell which one of the artists did what.

62.

Manifesto:

2. To affect, or bring to a certain state, by subjecting to, or treating with, a flux. "*Flu*red into another world." *South.*
3. *Med.* To cause a discharge from, as in purging.

flux (flŭks), n. [OF., fr. L. *fluxus*, fr. *fluere, fluxum*, to flow. See FLUENT; cf. FLUSH, n. (of cards).] **1.** *Med.* **a** A flowing or fluid discharge from the bowels or other part; esp., an excessive and morbid discharge; as, the bloody *flux*, or dysentery. **b** The matter thus discharged.

<u>Purge</u> the world of bourgeois sickness, "intellectual", professional & commercialized culture, PURGE the world of dead art, imitation, artificial art, abstract art, illusionistic art, mathematical art, — PURGE THE WORLD OF "EUROPANISM"!

2. Act of flowing: a continuous moving on or passing by, as of a flowing stream; a continuing succession of changes.
3. A stream; copious flow; flood; outflow.
4. The setting in of the tide toward the shore. Cf. REFLUX.
5. State of being liquid through heat; fusion. *Rare.*

PROMOTE A REVOLUTIONARY FLOOD AND TIDE IN ART,
Promote living art, anti-art, promote NON ART REALITY to be ~~fully~~ grasped by all peoples, not only critics, dilettantes and professionals.

7. *Chem. & Metal.* **a** Any substance or mixture used to promote fusion, esp. the fusion of metals or minerals. Common metallurgical fluxes are silica and silicates (acidic), lime and limestone (basic), and fluorite (neutral). **b** Any substance applied to surfaces to be joined by soldering or welding, just prior to or during the operation, to clean and free them from oxide, thus promoting their union, as rosin.

<u>FUSE</u> the cadres of cultural, social & political revolutionaries into united front & action.

George Maciunas, *Fluxus Manifesto* 1963

sonderdruck fluxus 2-3-if'63 maciunas manifest

63.

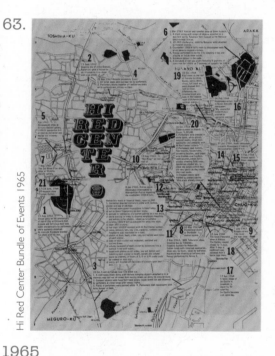

Hi Red Center Bundle of Events 1965

1963 **1965**

62. The Fluxus Manifesto reveals George Maciunas' central mission: to challenge the commercial art market and the bourgeois separation of art from life. Fluxus was to be part of the wider Socialist victory. Writing to Emmet Williams in June 1963 Maciunas asked: 'I must know how you feel about involving Fluxus with your party [...] Our activities lose all significance if divorced from socio-political struggle'.

63. Hi Red Center were active in Tokyo between 1963 and 1964. The three principal members were Takamatsu Jiro, Akasegawa Genpei and Nakanishi Natsuyuki and the group were aligned with the international Fluxus movement and the Japanese New Left. They orchestrated several performances and happenings which were designed to bring art out of the gallery and onto the street. The map shown above

demonstrates the groups' various attempts to infiltrate the urban infrastructure of the city, through direct action and subversive gestures. Their last performance *Cleaning Event* took place in 1964 on the seventh day of the Tokyo Olympic Games. The three core members, dressed in lab coats, meticulously cleaned the pavements with toothbrushes. Hi Red Center like other factions of the Japanese New Left were

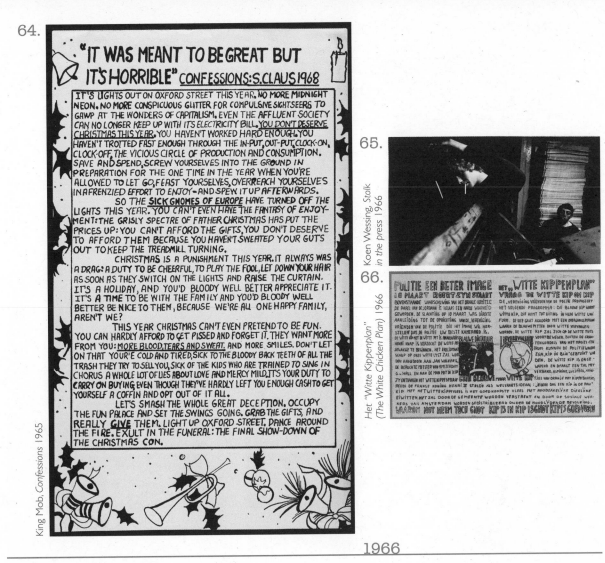

64.

65.

66.

Koen Wessing, Stolk in the press 1966

Het "Witte Kippenplan" (The White Chicken Plan) 1966

King Mob, Confessions 1965

1966

part of a protest movement against the stationing of US troops in Japan as part of the Vietnam War and the action was intended as a as a comment on the use of the Olympics to 'clean up' Japan's tarnished international image after WWII.

64. King Mob was a radically political UK-based collective, related to Situationist International. This leaflet was distributed as part of a legendary action that took place in Selfridges around Christmas. A member of the group dressed as Santa Claus tried to give away all of the shop's toys to children until the police were called, arrested Santa Claus and forced the children to give the toys back.

65, 66. Provo was a Dutch activist movement operating between 1965 and 1967. It is best known for using the format of playful and non-violent artistic happenings to provoke absurd overreactions from governmental forces. One of their most famous actions, *The White Bicycle Plan*, proposed to close central Amsterdam to motorised traffic and involved a scheme of 20,000 publicly shared bicycles to be left unlocked to be freely used by citizens as a self-regulatory system. When the proposal was rejected, Provo painted hundreds of bikes white and left them for public use in the city. The police returned them to the group as it was illegal to leave them unlocked. The group then equipped them with combination locks and painted the codes on the bike's frames. The plan has inspired many community bicycle programmes since.

67.

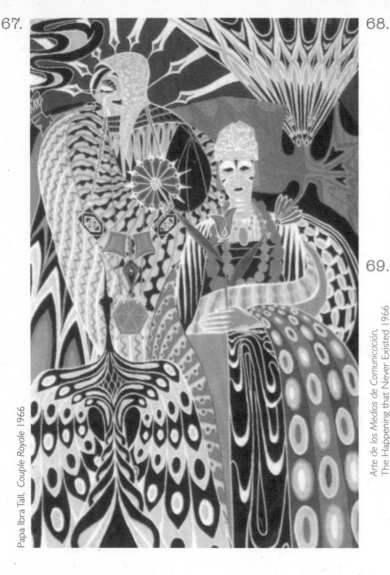

Papa Ibra Tall, *Couple Royale* 1966

68.

69.

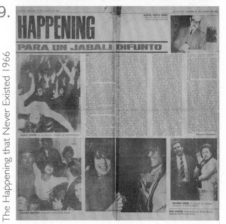

Arte de los Medios de Comunicación,
The Happening that Never Existed 1966

67. When Leopold Senghor proclaimed Senegal a republic in 1960, one of his first actions was to found the Ecole de Dakar. He believed the arts to be essential for the development of a new pan-African socialism derived from Marxist tenets. He saw the visual arts as a way to create a universal common language that could unite people across the globe of any nationality and race to fight for a new socialism informed by African values and culture. His idea for a new art was based on the philosophy of Negritude he had helped to develop. Papa Ibra Tall's work shows an artist consciously applying the Senghorian ideas about how African Socialist and Negritude philosophies could consciously be applied to art-making practice. His work fused traditional African textile techniques with modern technologies and drew heavily from the historic concern with geometry, pattern and vibrant colour that has characterised African Art.

68, 69. *Un arte de los medios de comunicación* (Mass Media Art) were a group of artists who used communication circuits as their medium. They fabricated 'happenings' like this 'fictional happening', where live accounts and staged photographs were fed to newspapers to reach a mass audience using existing distribution networks.

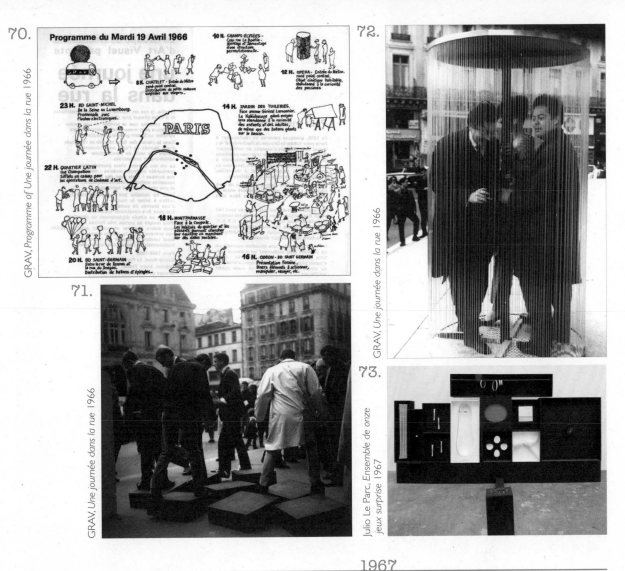

70. *GRAV, Programme of Une journée dans la rue 1966*

Programme du Mardi 19 Avril 1966

72. *GRAV, Une journée dans la rue 1966*

71. *GRAV, Une journée dans la rue 1966*

73. *Julio Le Parc, Ensemble de onze jeux surprise 1967*

1967

70, 71, 72, 73. The Groupe de Recherche d'Art Visuel (GRAV) was comprised of 11 members associated with the New Left, including Julio Le Parc, Francois Morrellet and Yvaral. Influenced by Yvaral's father Victor Vasarely they aimed to challenge the idea of the individual artistic genius through the fusion of collective work and scientific research.

GRAV: TRANSFORMING THE CURRENT SITUATION IN THE PLASTIC ARTS (1961/2)
Artist-Society Relationship

This relationship is currently based on:
- The unique and isolated artist
- The cult of personality
- The myth of creation
- Aesthetic (or overrated anti-aesthetic) conventions
- Creation for the elite
- The production of unique works
- Dependence on the art market
Proposals for transforming this relationship
- Strip the conception and creation of the work of all mystification and reduce them to a simple human activity.

- Search for new means of contact with the public with works thus created.
- Eliminate the category of 'work of art' and its myths.
- Develop new forms of estimation.
- Create multiplicable works
- Search for new categories of creation beyond painting and sculpture.
- Free the public from inhibitions and distortions in their appreciation produced by traditional aesthetics, by creating a new artist-society situation.

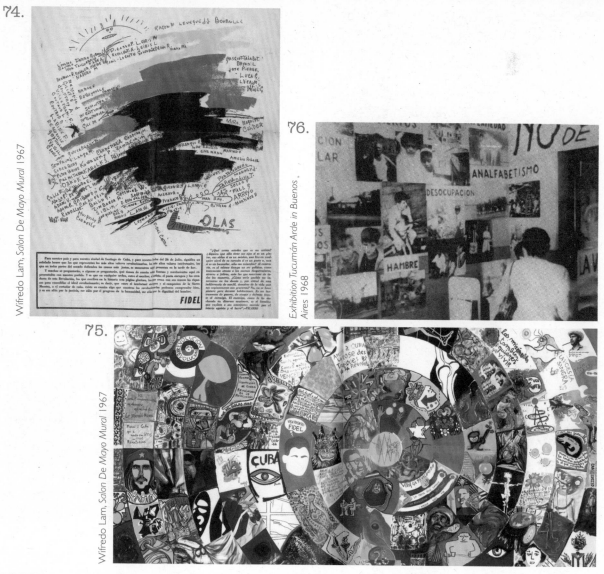

74.

76.

Wifredo Lam, Salon De Mayo Mural 1967

Exhibition Tucumán Arde in Buenos Aires 1968

75.

Wifredo Lam, Salon De Mayo Mural 1967

74, 75. In 1967 the Cuban artist Wifredo Lam invited more than one hundred artists and intellectuals to Havana to re-stage the Paris Salon de Mai exhibition. On the night of July 17, 1967, the group came together as a collective to create a huge painted mural measuring 11x5 metres that expressed solidarity with the Cuban Revolution. The process of producing the mural was a performance in itself, taking place over three days and drawing large crowds who sang and danced to the accompanying brass bands. At Lam's suggestion, canvases were attached to a wooden grid, a spiral was drawn on the surface, and the form was divided into approximately one hundred areas for painting. The centre space was saved for Lam, and field 26 was saved for Fidel Castro though it was never filled.

76. Tucumán Arde was a collective project titled after a region in Argentina known for its production of sugar. At the time of the group's inception, there was political unrest surrounding the working conditions in the sugar factory. The group gathered documentary evidence in collaboration with the Trade Unions and used various different pedagogical and presentation formats for their

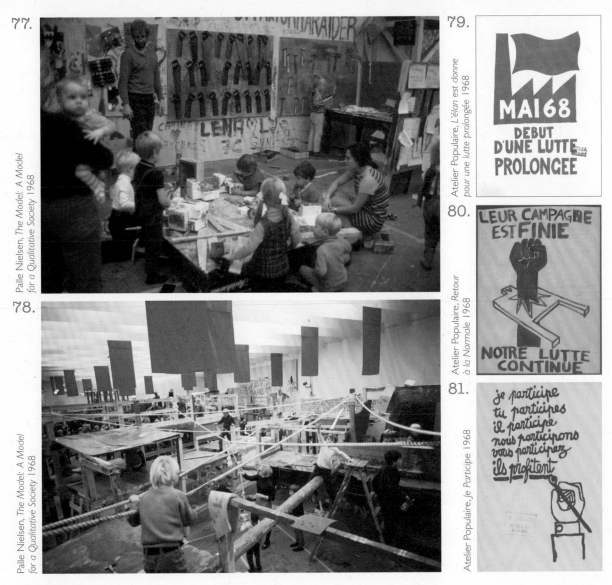

77.

Palle Nielsen, *The Model: A Model for a Qualitative Society* 1968

78.

Palle Nielsen, *The Model: A Model for a Qualitative Society* 1968

79.

Atelier Populaire, *L'élan est donné pour une lutte prolongée* 1968

MAI 68
DEBUT D'UNE LUTTE PROLONGEE

80.

Atelier Populaire, *Retour à la Normale* 1968

LEUR CAMPAGNE EST FINIE
NOTRE LUTTE CONTINUE

81.

Atelier Populaire, *Je Participe* 1968

je participe
tu participes
il participe
nous participons
vous participez
ils profitent

1968

exhibitions to raise awareness of the problem and instigate responses from the public. The project was shut down by the police at its second iteration in Buenos Aires.

77, 78. *The Model: A Model for a Qualitative Society* was held at Moderna Museet in Stockholm. Conceived by Palle Nielsen in collaboration with the political activist group Aktion Samtal,

the museum was given over to children to construct their own space. Adults were allowed to observe, but not intervene, as the children interacted in the creation of their environment. University students were tasked with scientific observation meant to investigate if any social or governmental model emerging from the children's interaction could be used to conceive of a new society.

79, 80, 81. During the May 1968 student protests in Paris, some students and teachers took over the Ecole des Beaux Arts and formed Atelier Populaire (Popular Workshop). Working anonymously, they produced hundreds of posters of a particular aesthetic style. The posters were considered to be an inseparable part of the political struggle, belonging in the public realm.

82.

COMRADES,

What we have already done in France is haunting Europe and will soon threaten all the ruling classes of the world, from the bureaucrats of Moscow and Beijing to the millionaires of Washington and Tokyo. Just as we have made Paris dance, the international proletariat will once again take up its assault on the capitals of all the states and all the citadels of alienation. The occupation of factories and public buildings throughout the country has not only brought a halt to the functioning of the economy, it has brought about a general questioning of the society. A deep-seated movement is leading almost every sector of the population to seek a real transformation of life. This is the beginning of a revolutionary movement, a movement which lacks nothing but the consciousness of what it has already done in order to triumph.

Address To All Workers, by Situationist International Committee Council for Maintaining the Occupations 30/05/1968

83.

Situationist International, *Detournément* translates as 'Sure we know what guns are for…Where can you house us?', "Come with me!"

84.

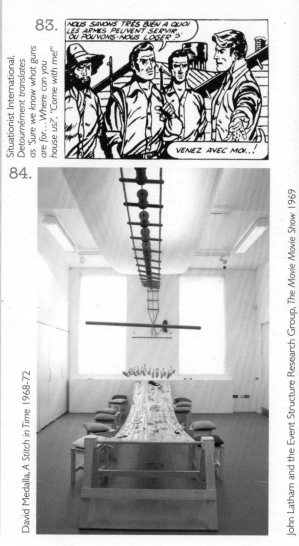

David Medalla, *A Stitch in Time* 1968-72

85.

John Latham and the Event Structure Research Group, *The Movie Movie Show* 1969

1968-72

1969

82. Situationist International were also involved in these student protests, and issued this statement regarding the occupation of the Sorbonne University.

83. Situationist International was founded in the early 1960s and sprang from the idea that there is no art, and no ownership of art, only situations to be created using images, text or action. A main mode of production for the Situationists was the 'détournement' (literally derailment), in which existing images were 'détourned' or appropriated into a different situation using juxtapositions of incongruous text.

84. In 1968 David Medalla created *A Stitch in Time*, a work relating to what the artist described as his 'marxist period', and a time in which he was particularly interested in the cloth production industry, and labour in general. Members of the public are invited to stitch their 'hopes, dreams, poems, etc.' onto a cloth, building the work during its display.

85. The Black-E was founded in Liverpool by Wendy and Bill Harpe in 1968 creating the UK's first community arts project. One of their first events was *The Movie*

86.

WHAT IS TO BE DONE?

1. We must make political films.
2. We must make films politically.
3. 1 and 2 are antagonistic to each other & belong to two opposing conceptions of the world.
4. 1 belongs to the idealistic and metaphysical conception of the world.
5. 2 belongs to the Marxist and dialectical conception of the world.
6. Marxism struggles against idealism and the dialectical against the metaphysical.
7. This struggle is the struggle between the old and the new, between new ideas and old ones.
8. The social existence of men determines their thought.
9. The struggle between the old and the new is the struggle of classes.
10. To carry out 1 is to remain a being of the bourgeois class.
11. To carry out 2 is to take up a proletarian class position.
12. To carry out 1 is to make descriptions of situations.
13. To carry out 2 is to make concrete analysis of a concrete situation.
14. To carry out 1 is to make BRITISH SOUNDS.

Jean-Luc Godard, *What is to be Done? Manifesto* (extract) 1970

88.

Transfer: The Maintenance of the Art Object © 1973

Museum Maintenance Rule: only the conservator is empowered to touch the art object, handle it, clean it.

1. Selection of the Art Object in the Museum:
 Mummy (female figure) in glass case.

2. Activity: 3 people → same task → Museum → 3 powers

Activity	Person	Task	Result
	Maintenance Person	Clean the glass mummy case, (as usual).	A clean glass mummy case
	Mierle Laderman Ukeles, Maintenance Artist	Clean the glass mummy case: ("dust painting"). (Stamp glass case as Original Maintenance Art) (Maintenance Person can no longer touch it.)	A Maintenance Art Work
	Museum Conservator	Perform conservation condition examination: Art Work is "Dusty. Requires superficial cleaning." Clean the glass mummy case	A clean Maintenance Art Work

Mierle Ukeles Laderman, Transfer: The Maintenance of the Art Object 1973

87.

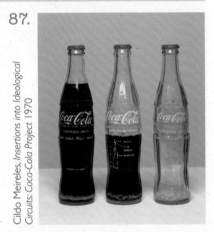

Cildo Meireles, Insertions into Ideological Circuits: Coca-Cola Project 1970

1970

Movie Show, with John Latham and the Event Structure Research Group. The purpose of the event was to break down any hierarchies between audience and film/performance, attempting, as stated in the programme, 'to bridge the gap between the fantasies of the possible film and the possibilities of everyday living'.

86. Taking its name from Lenin's famous statement, 'What is to be Done?', Jean-Luc Godard's manifesto outlines his intentions for film making, eschewing narrative film in favour of disjunctive elements which incite fresh responses to every situations from the audience, recalling Brechtian learning plays.

87. These Coca-Cola bottles are part of Cildo Meireles' multi-part project *Insertions into Ideological Circuits*, in which the artist used existing distribution streams to spread subversive anti-American messages, at a time when the Coca-Cola symbolised American imperialism in Brazil. The bottles were printed with instructions of how to make a Molotov cocktail, and then submitted to the recycling plant to be reused.

88. Mierle Ukeles Laderman's series *Maintenance Works* comprise the artist carrying out ordinary maintenance duties, for example dusting a wall becomes a 'dust work', making domestic, typically female, labour visible.

89.

Question:

Would the fact that Governor Rockefeller has not denounced President Nixon's Indochina policy be a reason for you not to vote for him in November?

Answer:

If 'yes'
please cast ... t into the left box;
if 'no'
into the r...

Hans Haacke, *MoMA Poll* 1970

WITH REGARDS TO ART MUSEUMS IN GENERAL THE ART WORKERS' COALITION MAKES THE FOLLOWING DEMANDS:

1. The Board of Trustees of all museums should be made up of one-third museum staff, one-third patrons, and one-third artists, if it is to continue to act as the policy-making body of the museum. All means should be explored in the interest of a more open-minded and democratic museum. Art works are a cultural heritage that belongs to the people. No minority has the right to control them; therefore, a board of trustees chosen on a financial basis must be eliminated.

2. Admission to all museums should be free at all times, and they should be open evenings to accommodate working people.

3. All museums should decentralize to the extent that their activities and services enter Black, Puerto Rican, and all other communities. They should support events with which these communities can identify and control. They should convert existing structures all over the city into relatively cheap, flexible branch-museums or cultural centres that could not carry the stigma of catering only to the wealthier sections of society.

4. A section of all museums under the direction of Black and Puerto Rican artists should be devoted to showing the accomplishments of Black and Puerto Rican artists, particularly in those cities where these (or other) minorities are well represented.

5. Museums should encourage female artists to overcome centuries of damage done to the image of the female as an artist by establishing equal representation of the sexes in exhibitions, museum purchases, and on selection committees.

6. At least one museum in each city should maintain an up-to-date registry of all artists in their area, that is available to the public.

7. Museum staffs should take positions publicly and use their political influence in matters concerning the welfare of artists, such as rent control for artists' housing, legislation for artists' rights, and whatever else may apply specifically to artists in their area. In particular, museums, as central institutions, should be aroused by the crisis threatening man's survival and should make their own demands to the government that ecological problems be put on par with war and space efforts.

8. Exhibition programs should give special attention to works by artists not represented by a commercial gallery. Museums should also sponsor the production and exhibition of such works outside their own premises.

9. Artists should retain a disposition over the destiny of their work, whether or not it is owned by them, to ensure that it cannot be altered, destroyed, or exhibited without their consent.

UNTIL SUCH TIME AS A MINIMUM INCOME IS GUARANTEED FOR ALL PEOPLE, THE ECONOMIC POSITION OF ARTISTS SHOULD BE IMPROVED IN THE FOLLOWING WAYS:

1. Rental fees should be paid to artists or their heirs for all work exhibited where admissions are charged, whether or not the work is owned by the artist.

2. A percentage of the profit realized on the re-sale of an artist's work should revert to the artist or his heirs.

3. A trust fund should be set up from a tax levied on the sales of the work of dead artists. This fund would provide stipends, health insurance, help for artists' dependents, and other social benefits.

Art Workers Coalition Statement of Demands 1970

1970

89. The question asked in Hans Haacke's *MoMA Poll* is 'Would the fact that Governor Rockefeller has not denounced President Nixon's Indochina policy be a reason for you not to vote for him in November?' Rockefeller was then on the board of trustees of MoMA, and planning to run for presidency in November. Nixon's Indochina policy refers to the American involvement in the Vietnam War and subsequent invasion of Cambodia.

90. The Art Workers Coalition was formed by artists, museum staff and critics to put pressure on art institutions regarding particular issues such as the inclusion in exhibition programme of art by women and people from ethnic minorities as well as joining demonstrations against the war in Vietnam. Active between 1969 and 1971, members of the group included artist Carl Andre, Dan Graham, Lee Lozano, Hans Haacke and curators Lucy Lippard, Seth Siegelaub and Willoughby Sharp.

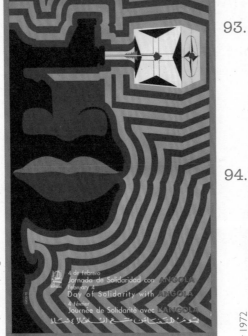

92.

Lucio Martinez, *International Day of Solidarity with the People and Students of Angola* 1972

4 de febrero
Jornada de Solidaridad con ANGOLA
February 4
Day of Solidarity with ANGOLA
4 février
Journée de Solidarité avec l'ANGOLA

93.

"When the Black Panthers started the paper the whole idea was to have lots of pictures and art because a segment of the African-American community wasn't a reading community. But they could see the pictures, or they might understand the captions and get the gist of what was going on"

Emory Douglas 2007

94.

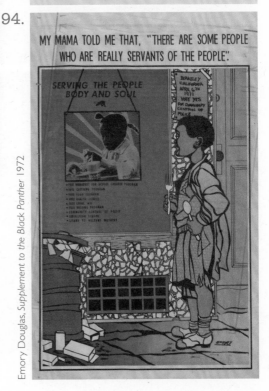

MY MAMA TOLD ME THAT, "THERE ARE SOME PEOPLE WHO ARE REALLY SERVANTS OF THE PEOPLE".

SERVING THE PEOPLE BODY AND SOUL

Emory Douglas, *Supplement to the Black Panther* 1972

91.

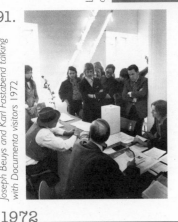

Joseph Beuys and Karl Fastabend talking with Documenta visitors 1972

1972

91. Joseph Beuys' practice in the 1970s often took the form of 'Social Sculpture', actions based on the belief that art can make a difference to society through the creation of situations enabling participation and interaction. For Documenta 5, Beuys' contribution was an office set up for the 'Organization for Direct Democracy by Referendum', which engaged the public in debate about art, politics and governance models.

92. The Organization of Solidarity with the People of Asia, Africa and Latin America (OSPAAAL) was founded in Cuba, following the Tricontinental conference in Havana which gave its name to the OSPAAAL magazine, *Tricontinental*. OSPAAAL aimed to fight imperialism and globalisation, distributing posters such as this to subscribers of the Tricontinental. The posters also found a place in the newly

communist public spaces of Havana, taking the places formerly occupied by adverts for American-endorsed companies to create a gallery on the street.

93, 94. The Black Panther newspaper was produced to reach more of the African American communities. Within two years it had a circulation of over 250,000.

101.

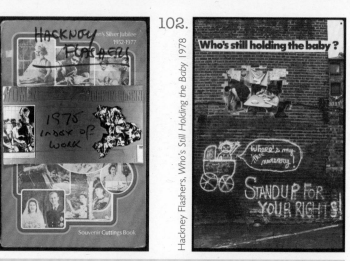

Hackney Flashers, *Scrapbook* 1975

102.

Hackney Flashers, *Who's Still Holding the Baby* 1978

103.

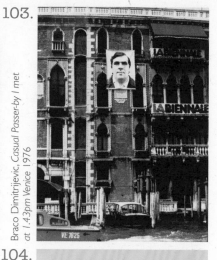

Braco Dimitrijevic, *Casual Passer-by I met at 1.43pm Venice* 1976

The refusal to labour is the chief weapon of workers fighting the system; artists can use the same weapon. To bring down the art system it is necessary to call for years without art, a period of three years - 1977 to 1980 - when artists will not produce work, sell work, permit work to go on exhibitions, and refuse collaboration with any part of the publicity machinery of the art world. This total withdrawal of labor is the most extreme collective challenge that artists can make to the state.

Excerpt from Art Strike, *Gustav Metzger 1977-1981*

104.

We share the belief that culture should no longer exist merely as an extension of the economic interests or the personal 'tastes' of the wealthy and powerful. Nor can we hope to transform culture outside of a struggle to transform the society from which it springs.

Artists Meeting for Cultural Change 1977

1975

1976

101, 102. The Hackney Flashers cooperative was formed in East London, with amateur and professional photographers working together. Their distinctive style includes morphing images and text to make work that deals with feminist issues such as the visibility of domestic labour and the problem of childcare in a female labour market. Works relating to the same issue are devised as exhibitions that could be rented by community centres, charging minimal amounts to cover ongoing production costs.

103. Braco Dimitrijevic's *Casual Passer By* series involves the artist taking a photograph of, literally, the man in the street, and enlarging it to monumental

proportions. These mammoth faces are then displayed in public places, such as on the hoardings of prominent buildings, or on the side of a London bus. This gives the common man a status comparable to other publicly displayed figures, normally historically significant, or celebrities. The egalitarian view proffered also reaches people, like the man on the street, who might not otherwise find themselves in contact with an artwork.

104. The *Anti-Catalog* by Artists Meeting for Cultural Change was prompted by a Whitney exhibition called *Three Centuries of American Art* which showcased the art collection of John D. Rockefeller, including only one African American and one women artist.

The publication became much more than a critique of this show, connecting social injustices with the cultural biases they cause.

free classes in the creative arts, and produced a journal, La Chachalaca, to provide a forum for discussion.

105. The Artist's Placement Group founded by Barbara Steveni, John Latham, Barry Flanagan and David Hall amongst others. The aim of the group was to negotiate invitations to artists to work within industries, such as British Steel, and with UK governmental departments. There was no expectation of particular outcomes from the placements as the principle was for artist and organisation to

105.

ARTIST PLACEMENT GROUP MANIFESTO

1. The context is half the work.

2. The function of medium in art is determined not so much by that factual object, as by the process and the levels of attention to which the work aims.

3. That the proper contribution of art to society is art.

4. That the status of artists within organisations must necessarily be in line with other professional persons, engaged within the organisation.

5. That the status of the artist within organisations is independent, bound by the invitation, rather than by any instruction from authority within the organisation, and to the long-term objectives of the whole of society.

6. That, for optimum results, the position of the artist within an organisation (in the initial stages at least) should facilitate a form of cross-referencing between departments.

106.

Roger Coward, You And Me Here We Are: What Can Be Said To Be Going On? Royal College of Art 1977

107.

Raphael Romero De Arce, Network of the Centros Populares de Cultura 1979

1977 1979

influence each other.

106. As part of the Artist Placement Group, Roger Coward worked with Birmingham town council, where with a group of fellow artists he instigated theatrical workshops and film interviews with the local inhabitants about the conditions of council housing in the Spaghetti Junction area.

107. In Nicaragua, the Sandinista National Liberation Front (FSLN) overthrew the dictator Anastasio Somoza in 1979, establishing a unique socialist revolutionary government in its place. The development of a 'people's culture' was a core part of the Sandinista's policy. The FSLN was composed of various left-wing groups, meaning it was not an orthodox Leninist party with a uniform and unyielding line on particular issues such as art. The new cultural program developed by the poet Ernesto Cardenal was therefore not to be a top down imposition of one particular cultural style but a new diverse national culture that would develop through ongoing dialogue with people at every level of Nicaraguan society, who should become the producers as well as the consumers of culture. The Sandinistas aimed to encourage the reclamation of indigenous and popular culture, which had been dismissed as 'low' art. The Ministry of Culture established a national network of Popular Centres for Culture (Centros Populares de Cultura) which contained libraries, provided

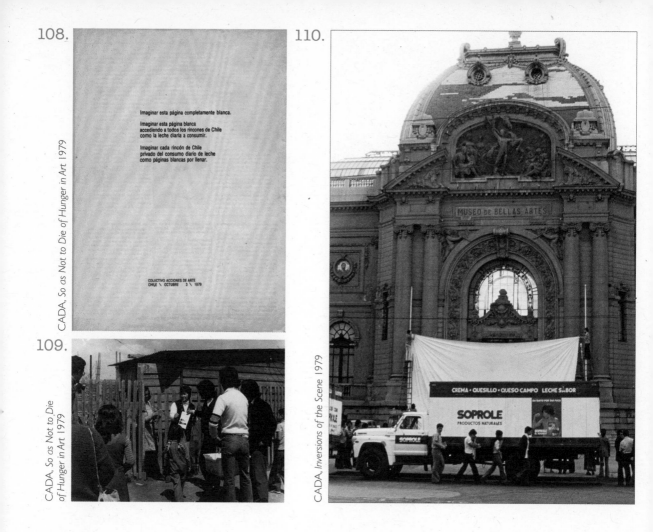

108.

Imaginar esta página completamente blanca.

Imaginar esta página blanca
accediendo a todos los rincones de Chile
como la leche diaria a consumir.

Imaginar cada rincón de Chile
privado del consumo diario de leche
como páginas blancas por llenar.

COLECTIVO ACCIONES DE ARTE
CHILE \ OCTUBRE 3 \ 1979

CADA, So as Not to Die of Hunger in Art 1979

109.

*CADA, So as Not to Die
of Hunger in Art 1979*

110.

CADA, Inversions of the Scene 1979

1979

108. Translation of text:
imagine this page completely
white

imagine this white page,
reaching all corners of Chile,
like daily milk to be consumed

imagine each corner of Chile
deprived of its daily ration of milk
as white pages to be filled in
Colectivo de Acciones de Arte/
Chile / October 3 / 1979

109, 110. CADA formed in Chile
under the Pinochet dictatorship,
comprising the visual artists Lotty
Rosenfeld and Juan Castillo, the
writers Diamela Eltit and Raúl
Zurita and the sociologist
Fernando Balcells. They decided
upon a strategy of 'art actions'
to actively intervene in the public
space of the city. These actions
investigated alternative modes of
distribution for art and literature
that would reach beyond the art

community in order to
interpolate into the wider
reading public. CADA's first action
To Not Starve to Death in Art (Para
No Morir de Hambre en el Arte)
involved distributing 100 litres of
milk to 100 families in the poor
La Granja municipality. The bag
that contained the milk was
printed on one side with the
simple phrase "1/2 litro de leche"
that described the physical
contents, and on the other side

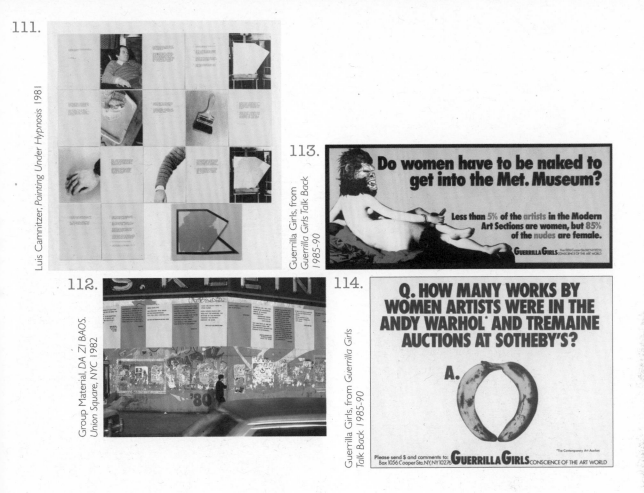

111.

Luis Camnitzer, *Painting Under Hypnosis* 1981

113.

Guerrilla Girls, from *Guerrilla Girls Talk Back* 1985-90

Do women have to be naked to get into the Met. Museum?

Less than 5% of the artists in the Modern Art Sections are women, but 85% of the nudes are female.

Guerrilla Girls CONSCIENCE OF THE ART WORLD

112.

Group Material, *DA ZI BAOS, Union Square, NYC* 1982

114.

Guerrilla Girls, from *Guerrilla Girls Talk Back* 1985-90

Q. HOW MANY WORKS BY WOMEN ARTISTS WERE IN THE ANDY WARHOL* AND TREMAINE AUCTIONS AT SOTHEBY'S?

A.

Please send $ and comments to: Box 1056 Cooper Sta. NY, NY 10276 **Guerrilla Girls** CONSCIENCE OF THE ART WORLD

*The Contemporary Art Auction

1981 1982 1985-90

they printed a text, which outlined the equivalence of the receiver and the art that used the milk as a support and distribution medium.

111. Luis Camnitzer realised a 'collaborative artwork' whilst under hypnosis, questioning the notion of the artist as a singular creative genius, as well as testing the limits of collective authorship.

112. Established in 1979, Group Material was an artist collective exploring political and social issues around democracy,

participation and civil rights. In the project Da Zi Baos (the word literally means large character report) the artists involved members of the public in the shaping of their art. Modelled after the posters originated by the Democracy Wall movement in China, the work aimed at occupying public space to give voice to dissent in a very popular and visible way. They aimed to achieve collective authorship and social inclusion by finding more equal ways for the production and reception of culture. Different iterations of the project were

carried out in Cardiff, New York and Berkeley throughout the 1980s. Members of the group include Doug Ashford, Julie Ault, Felix Gonzalez-Torres, Karen Ramspacher and Tim Rollins.

113, 114. The Guerilla Girls, an anonymous collective of artists, were founded in New York as response to a MoMA exhibition that featured only 13 women out of 167 presented artists. Their posters and performances reveal and protest the inequalities of the art world.

Zvono Group, Art and Soccer 1986

116.

Martha Rosler, If You Lived Here Still c.1988-2011

1986

1988-2011

115. Zvono Group (or Bell Group, taking the name of the Bell Café where the artists meet) performed actions in Sarajevo. Taking the form of interventions in public spaces such as busy shopping streets and football fields, the artists wanted their actions to be experienced collectively in the public realm like the actions of sportsmen or musicians.

116. Martha Rosler worked with activists, architects and urban theorists, alongside a group of homeless people called Homeward Bound, in a collaborative project to explore the extent of the problem of homelessness in New York. The conglomeration of multifarious material gathered from these different perspectives gives an indication of the complexity of the problem while also giving a voice to the marginalised homeless people. Each time the work is displayed, material relating to gentrification and housing in the local context is added.

117.

Image of Exhibition of Telearte VI 1989

118.

Tim Rollins, K.O.S. Amerika – For Karl 1989

1989

117. In 1983 the Cuban Ministry of Culture began an experimental art project called *Telearte* which aimed to bring more people into contact with the work of fine artists through mass distribution. They invited both local and international artists to contribute designs for textiles which were printed in runs of up to thirty thousand metres, sold by the yard and made into dresses, shirts and banners. For the Second Biennial of Havana a motif based on a Wifredo Lam symbol was transformed into a Telearte textile design by Umberto Peña. According to Luis Camnitzer, during the event Havana was festooned with Telearte banners bearing the design, and local people wore dresses and tops made from the fabric so that the whole city was transformed into a living artwork. Robert Rauschenberg contributed a design in 1989, shown in the photograph above.

118. In 1981 Tim Rollins was recruited to develop a curriculum for a public school in South Bronx that combined art making with reading, particularly focussed at a group of 'at-risk' students. These students became known as K. O. S. (Kids of Survival), and the works they have created together with Rollins, since encompassing many different students, have been exhibited internationally.

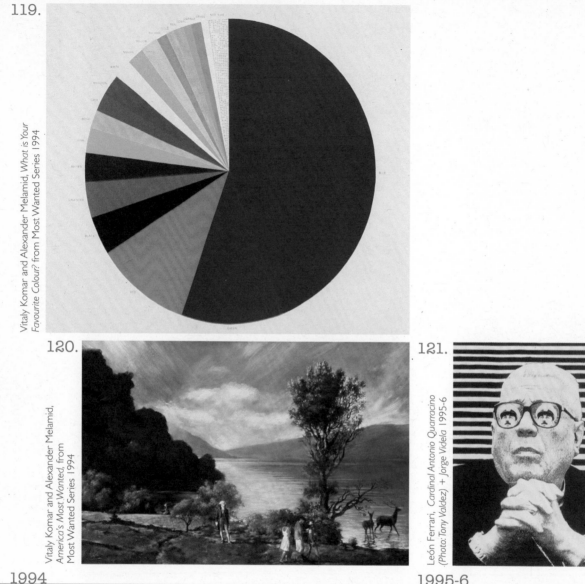

119.

Vitaly Komar and Alexander Melamid, *What is Your Favourite Colour?* from Most Wanted Series 1994

120.

Vitaly Komar and Alexander Melamid, *America's Most Wanted*, from Most Wanted Series 1994

121.

León Ferrari, *Cardinal Antonio Quarracino (Photo: Tony Valdez) + Jorge Videla* 1995-6

1994

1995-6

119, 120. Komar and Melamid devised the *Most Wanted* series based on the results of surveys, commissioning polling companies in eleven countries-including the United States, Russia, China, France, and Kenya-to discover what the aspects of art the populations of each country most and least desired. For example, they worked out the percentage of different colours to use and used the same method of equal apportionment to work out how much of the picture plane should be dedicated to each subject. The project consisted of the 'most wanted' and 'most unwanted' paintings of 11 countries, offering a satirical vision of democracy in action within the arts.

121. Works from Leon Ferrari's *Never Again* series acted as covers for a report into the investigation into 'disappeared people' during the military dictatorship in Argentina between 1976 and 1983, published in instalments by the newspaper *Página/12*. During this period Ferrari was exiled in Brazil, but read in the Argentinian newspapers about the many disappearances of this time. He also made a work comprising of clippings he took of these news stories, called, ironically, *We Did Not Know*.

An art grounded in distributed media can be seen as a political art and an art of communicative action, not least because it is a reaction to the fact that the merging of art and life has been effected most successfully by the "consciousness industry". The field of culture is a public sphere and a site of struggle, and all of its manifestations are ideological. In Public Sphere and Experience, Oscar Negt and Alexander Kluge insist that each individual, no matter how passive a component of the capitalist consciousness industry, must be considered a producer (despite the fact that this role is denied them). Our task, they say, is to fashion "counter-productions." Kluge himself is an inspiration: acting as a filmmaker, lobbyist, fiction writer, and television producer, he has worked deep changes in the terrain of German media. An object disappears when it becomes a weapon.

Seth Price, *Dispersion* (extract)
2002

122.

Irwin, *Retroavantgarda 2000*

Jeremy Deller and Alan Kane,
Folk Archive Banner, By Ed Hall 2005

123.

2000 2005

122. In the 1990s, Peter Weibel launched a discursive matrix in an exhibition catalogue of the Steierische Herbst (Graz) in which he coded the ex-Yugoslav territory from 'outside', subsuming the productions of Mladen Stilinovic (Zagreb), the 1980s Kasimir Malevich (Belgrade) and IRWIN (Ljubljana) under a common signifier: the 'Retroavantgarde.' I developed a dialectical interrelationship within which I designated their positions as those in a Hegelian tried: Mladen Stilinovic as thesis;

Malevich and the projects of copying as an antithesis; and IRWIN, with the projects of the NSK EMBASSIES as synthesis. All three artists, groups or art projects utilize specific strategies of visualisation to display aspects of Socialist and post-Socialist ideology.
Text by Marina Grzinic, from bottom right of image.

123. Between 2000 and 2006 Jeremy Deller and Alan Kane travelled the UK gathering varied and often eccentric visual material

made by non-art professionals. Roughly grouped into categories such as Home, Politics, Publishing and Performance, it includes houses people have decorated, graffiti made in public places, and 'folk' performances such as *The Burry Man*, which involves a costume being worn during an annual village fete. This banner was made by Ed Hall who began making trade union and protest banners in his garage during the 1980s.

124.

Ruth Ewan, *A Jukebox of People Trying to Change the World* 2003 – ongoing

126.

Chto Delat, *Partisan Songspiel: A Belgrade Story* 2009

125.

Wendelien van Oldenborgh, *Après la reprise, la prise* 2009

2009

124. The songs available for playing in Ruth Ewan's fully functional *A Jukebox of People Trying to Change the World* have been compiled by the artist from a combination of research and public suggestions. The viewer is encouraged to select a song, all broadly politically progressive in motivation, from categories such as 'the military', 'civil rights' and 'poverty'. Suggestions can be sent to jukebox@ruthewan.com.

125. At the end of the 1990s the factories making Levi's in France and Belgium were threatened with closure, causing the predominantly female workforce of around 2000 people to fight for their jobs. They offered to take a 10% pay reduction, but the factories shut nonetheless. Following this, the former Levi's workers took part in a theatre writing workshop instigated by dramatist Bruno Lajara, and

collaboratively wrote a play based on their experiences called *501 Blues* which toured France starring some of the workers for two years. Made about a decade after the closure of the factories, *Après le reprise, la prise* presents two of the now-actresses meeting trainee technicians about to enter the world of work, discussing the relationship between the conditions of work, and the conditions of cultural production.

128.

Goldin+Senneby, *Money will be like dross: Alchemy furnace of August Nordenskiöld (1754-1792). Inventory number: 60.749. Loan: Nordiska Museet, Sweden. Installation view: Material Information, Bergen 2012*

129.

Christopher Kulhendran Thomas, www.when-platitudes-become-form.lk 2013

127.

Adam Broomberg and Oliver Chanarin, *War Primer 2* 2011·

2011 2012 2013

126. Chto Delat's *Songspiel* films adopt Brecht's theories of creating a feeling of distance and alienation in the viewer by making visible formal constructs, in a retelling of communist history.

127. *War Primer 2* reworks Bertold Brecht's *War Primer*, retaining Brecht's four line epigrams but replacing the World War 2 photographs with images from the 2003 Iraq War.

128. In the late 18th century, Gustav III, King of Sweden, hired the alchemist August Nordenskiold, to create gold. The King wanted to become incredibly wealthy, but the alchemist was secretly an anarchist and wanted to use the King's backing to flood the market with lots of gold, making it worthless and destroying monetary systems. Goldin+Senneby's *Money will be like Dross* includes an exact replica of an original alchemic furnace, along with an instruction manual on how to constuct it. The work is uneditioned, but each time one is sold the price increases, reversing the normal market system where the rarer an item is, the more expensive it is. Here, as the work becomes less rare, it becomes more expensive.

129. This work is part of Christopher Kulhendran Thomas' ongoing project which takes as its material the system of art distribution. Kulhendran Thomas buys works by emerging artists in his native Sri Lanka, who have been facilitated by the newly formed economic boom following the suppression of civil unrest in the conflict with the northern Tamil part of the country. He then adapts them to conform with dominant trends in contemporary western art, sells them and uses the profits to fund online platforms offering forum theatre workshops to the victims of the civil war.

IMAGE CREDITS

76 *AL 21 Foto Muestra Tucumán Arde En Buenos Aires* 1966-68
© reserved
77, 78 Palle Nielsen, *The Model: A Model for a Qualitative Society* 1968
MACBA Museu d'Art Contemporani de Barcelona
© Palle Nielsen, VEGAP, Barcelona / DACS 2013.
79, 80, 81 Atelier Populaire, *L'élan est donne pour une lutte prolongée* 1968; *Retour à la Normale* 1968; *Je Participe* 1968
© Archivo Seneuroto - Antonio Ricci (Italy).
83 Situationist International, *Detournément* translates as 'Sure we know what guns are for… Where can you house us?', "Come with me!"
© reserved. 'Guy Debord and the Situationist International Texts and Documents edited by Tom McDonough', The MIT Press.
84 David Medalla, *A Stitch in Time* 1968-72
© Arts Council Collection, Southbank Centre, London. Photo: Stuart Whipps.
85 John Latham and the Event Structure Research Group, *The Movie Movie Show* 1969
87 Cildo Meireles, *Insertions into Ideological Circuits: Coca-Cola Project* 1970
© ADAGP, Paris and DACS, London 2002.
88 Mierle Ukeles Laderman, *Transfer: The Maintenance of the Art Object* 1973
Courtesy of Ronald Feldman Fine Arts, New York.
89 Hans Haacke, *MoMA Poll* 1970
© DACS, 2013.
91 *Joseph Beuys and Karl Fastabend talking with documenta visitors* 1972
© DACS 2013.
92 Lucio Martinez, *International Day of Solidarity with the People and Students of Angola* 1972
IISG BG D12/860, International Institute of Social History (Amsterdam).
94 Emory Douglas, *Supplement to the Black Panther,* 1971
© Emory Douglas / DACS 2013. IISG BG D18/246, International Institute of Social History (Amsterdam).
95 Li Chenua *The brigade's ducks* 1973
IISG BG E13/352, International Institute of Social History (Amsterdam).
96 *Chao Yi-min, Party committee secretary of Taiping Commune, comes to see peasant painters at a sparetime art class* 1974
IISG BG B31/774, International Institute of Social History (Amsterdam).
97 Mary Kelly, Margaret Harrison and Kay Hunt *Women & Work: a document on the division of labour in industry,* 1973-75
Installation, South London Gallery, 1975 Collection, Tate Britain.
98 Allan Sekula, *This Ain't China: A Photonovel* 1974
© Allan Sekula. Courtesy of the Artist and Christopher Grimes Gallery, Santa Monica.
99 Piero Gilardi, *Psichiatra Alternativa* 1974-82
© Artist & Guido Costa Projects.
101, 102 Hackney Flashers *Scrapbook* 1975; *Who's Still Holding the Baby* 1978
© The Jo Spence Memorial Archive.
103 Braco Dimitrijevic, *Casual Passer-by I met at 1.43pm Venice,* 1976
© Braco Dimitrijevic. Image courtesy Tate.
106 Roger Coward, *You And Me Here We Are: What Can Be Said To Be Going On?,* Royal College of Art 1977
Roger Coward's RCA Gallery exhibition "YOU AND ME HERE WE ARE – WHAT CAN BE SAID TO BE GOING ON?" (Oct-Nov 1977) hosting the APG "Incidental Person approach to Government" Conference. (27 Oct 1977)

107 Raphael Romero De Arce, *Network of the Centros Populares de Cultura* 1981
David Craven, 'Art and Revolution in Latin America 1910-1990', Yale University Press.
108, 109, 110 CADA, *So as Not to Die of Hunger in Art* 1979; *Inversions of the Scene* 1979
© CADA.
111 Luis Camnitzer, *Painting Under Hypnosis* 1981
© Luis Camnitzer.
112 Group Material, *DA ZI BAOS. Union Square, NYC* 1982
© Photo courtesy of Group Material.
113, 114 Guerrilla Girls, from *Guerrilla Girls Talk Back* 1985-90
© courtesy www.guerrillagirls.com. Image courtesy Tate.
115 Zvono Group, *Art and Soccer* 1986
© ZVONO.
116 Martha Rosler, *If You Lived Here Still* archive 1988-2011
Courtesy of the artist and Mitchell-Innes & Nash, NY.
117 Image of *Exhibition of Telearte VI* 1989
© Photo: Luis Camnitzer.
118 Tim Rollins, K.O.S., *Amerika - For Karl* 1989
© Tim Rollins and K.O.S.
Courtesy the artists and Lehmann Maupin, New York and Hong Kong.
119, 120 Vitaly Komar and Alexander Melamid, *What is Your Favourite Colour?* from Most Wanted Series 1994; *America's Most Wanted,* from Most Wanted Series 1994
Courtesy Ronald Feldman Fine Arts, New York / www.feldmangallery.com.
121 León Ferrari, *Cardinal Antonio Quarracino (Photo: Tony Valdez) + Jorge Videla* 1995-6
© Leon Ferrari. Image courtesy Tate.
Irwin, Retroavantgarda 2000.
122 IRWIN *"Retroavantgarde"* 2000/2009, Mixed media, Courtesy Galeria Gregor Podnar.
123 Jeremy Deller and Alan Kane, *Folk Archive Banner, By Ed Hall* 2005
© The Artists. Courtesy British Council Collection.
124 Ruth Ewan, *A Jukebox of People Trying to Change the World* 2003 – ongoing
© Ruth Ewan. Installation view Badischer Kunstverein, Karlsruhe 2012. Photo: Stephan Baumann, bild_raum.
125 Wendelien van Oldenborgh, *Après la reprise, la prise* 2009
© Courtesy Wilfried Lentz Rotterdam and the artist.
126 Chto Delat, *Partisan Songspiel: A Belgrade Story* 2009
Director: Tsaplya Olga Egorova, scriptwriters and stage designers: Vladan Jeremić, Dmitry Vilensky, costume design: Natalya Pershina Gluklya, choreography: Nina Gasteva, editing and post-production: Olga Egorova Tsaplya, Dmitry Vilensky. Production in Belgrade: Biro Beograd - Biro for Culture and Communication Belgrade, July 2009.
127 Adam Broomberg and Oliver Chanarin, *War Primer 2* 2011
Editions: Special edition of 100
Publisher: MACK Books.
128 Goldin+Senneby *Money will be like dross: Alchemy furnace of August Nordenskiöld (1754-1792).* Inventory number: 60.749. Loan: Nordiska Museet, Sweden. Installation view: Material Information, Bergen 2012.
129 Christopher Kulhendran Thomas, www.when-platitudes-become-form.lk 2013
© The Artist.

TATE LIVERPOOL THANKS THE FOLLOWING INDIVIDUALS AND ORGANISATIONS FOR THEIR GENEROUS SUPPORT:

The Art Fund
Biffa Award
The Bloxham Charitable Trust
Maria Rus Bojan
Business in the Arts: North West
The Culture Programme of the European Union
The Danish Arts Council Committee for
International Visual Arts
DLA Piper
The Duchy of Lancaster Benevolent Fund
The Eleanor Rathbone Charitable Trust
Embassy of Denmark, London
European Regional Development Fund (ERDF)
Gower Street Estates
The Granada Foundation
Melle Hendrikse
Liverpool City Council
Liverpool John Moores University
Liverpool Vision
LUMA Foundation
Mersey Care NHS Mental Health Trust
Merseytravel
National Lottery through Arts Council England
The Office for Contemporary Art Norway (OCA)
Paul Hamlyn Foundation
Sky Arts
Tate Americas Foundation
Tate Liverpool Members
Winchester School of Art, University of Southampton
Women's Caucus for Art, USA

Patrons:
Elkan Abrahamson
Diana Barbour
David Bell
Lady Beverley Bibby
Jo & Tom Bloxham MBE
Bill Clark
Jim Davies
Patricia Koch
Olwen McLaughlin
Barry Owen OBE
Sue & Ian Poole
Andy Pritchard
Alan Sprince

Corporate Partners:
Christie's
David M Robinson (Jewellery) Ltd
DLA Piper
Liverpool & Sefton Health Partnership
Liverpool Hope University
Liverpool John Moores University
Peel Ports
The University of Liverpool

Corporate Members:
Bruntwood
Cheetham Bell JWT
Choice Capital Management & AIMS Finance
Deutsche Bank
DWF
EY
Grant Thornton
Hill Dickinson
Kirwans
Lime Pictures
Mazars
Rathbone Investment Management
Unilever R&D Port Sunlight